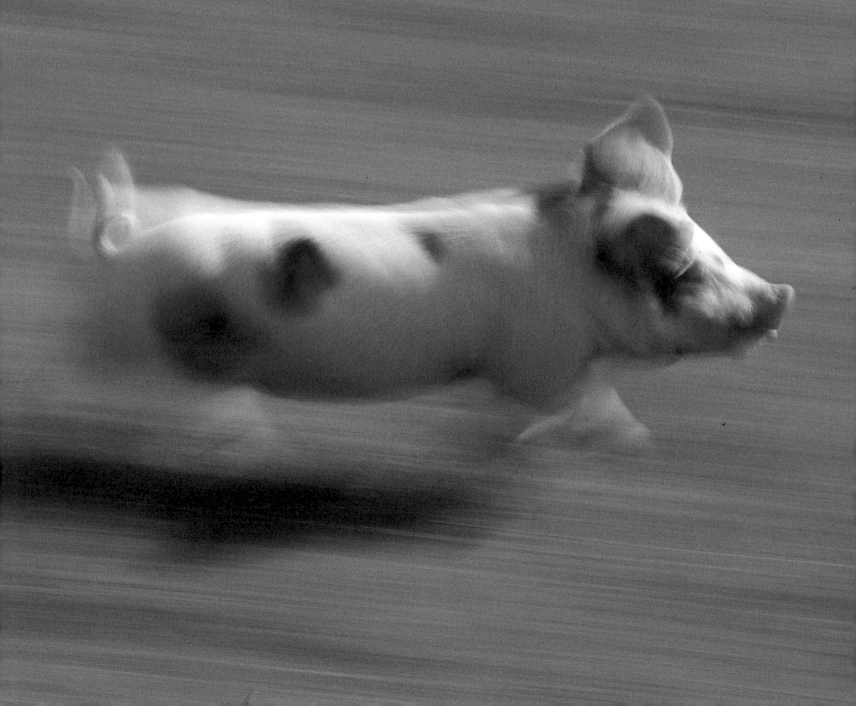

EXTRAORDINARY
PIGS

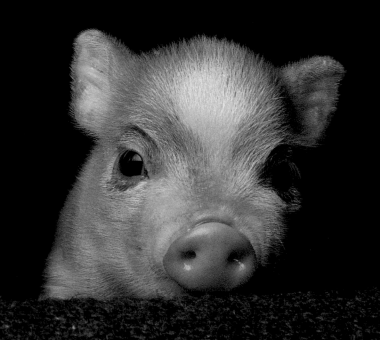

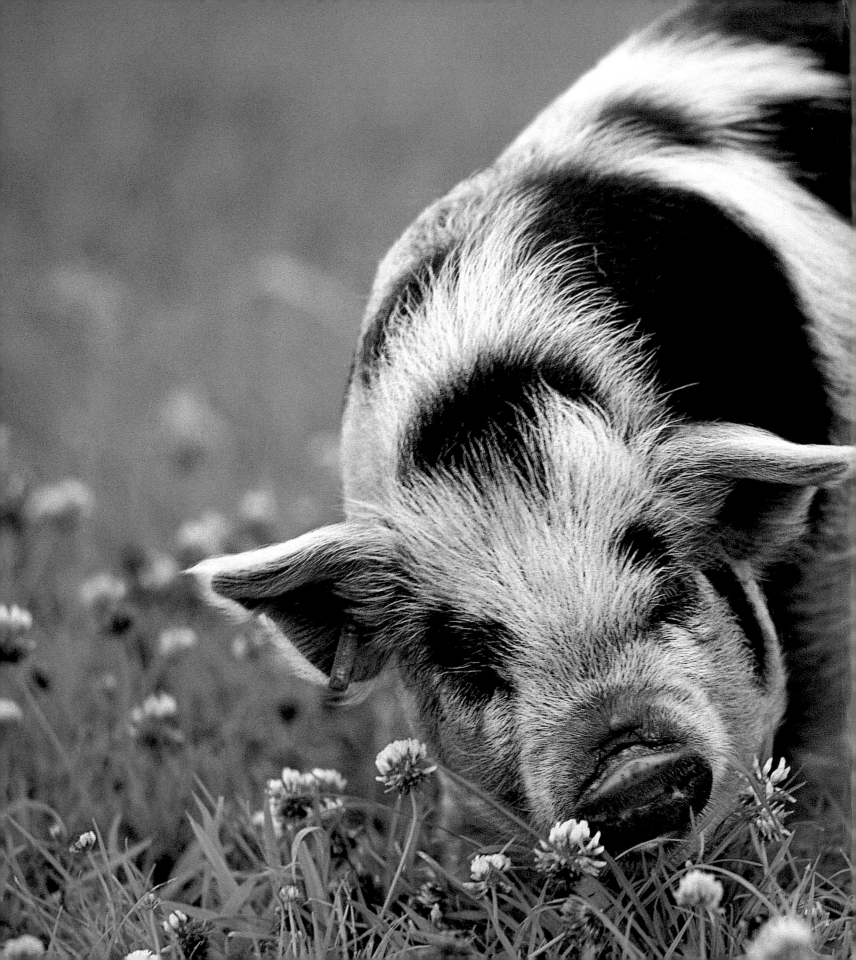

EXTRAORDINARY

PIGS

STEPHEN GREEN-ARMYTAGE

Abrams, New York

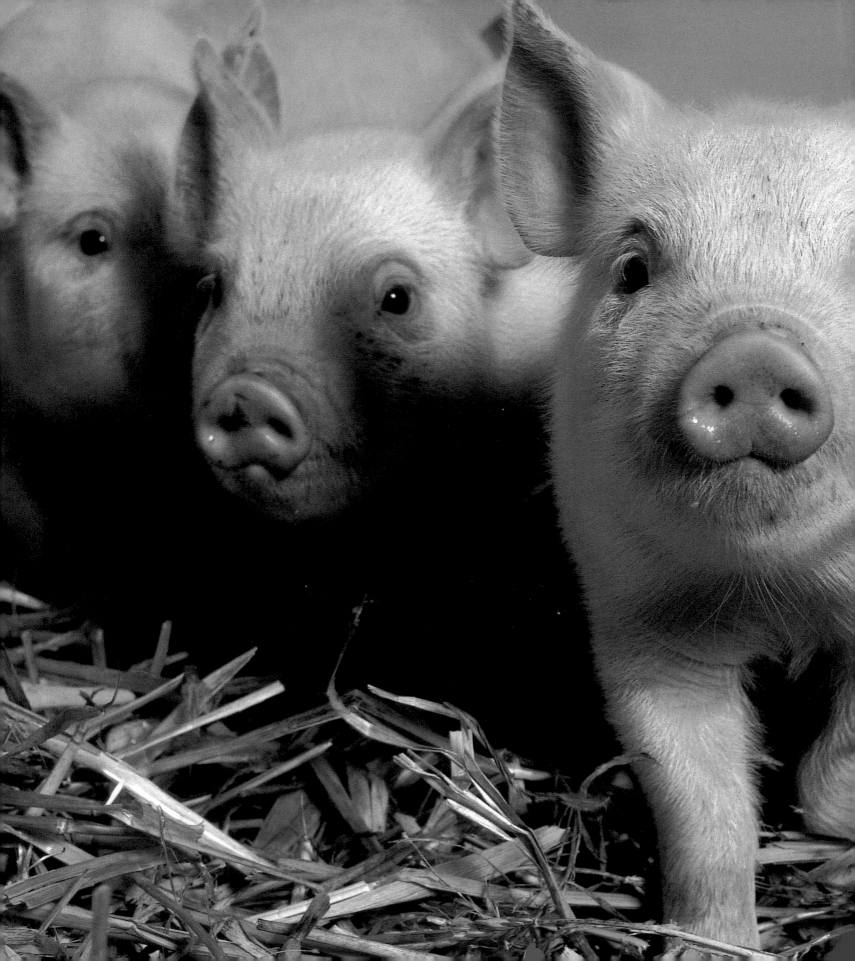

CONTENTS

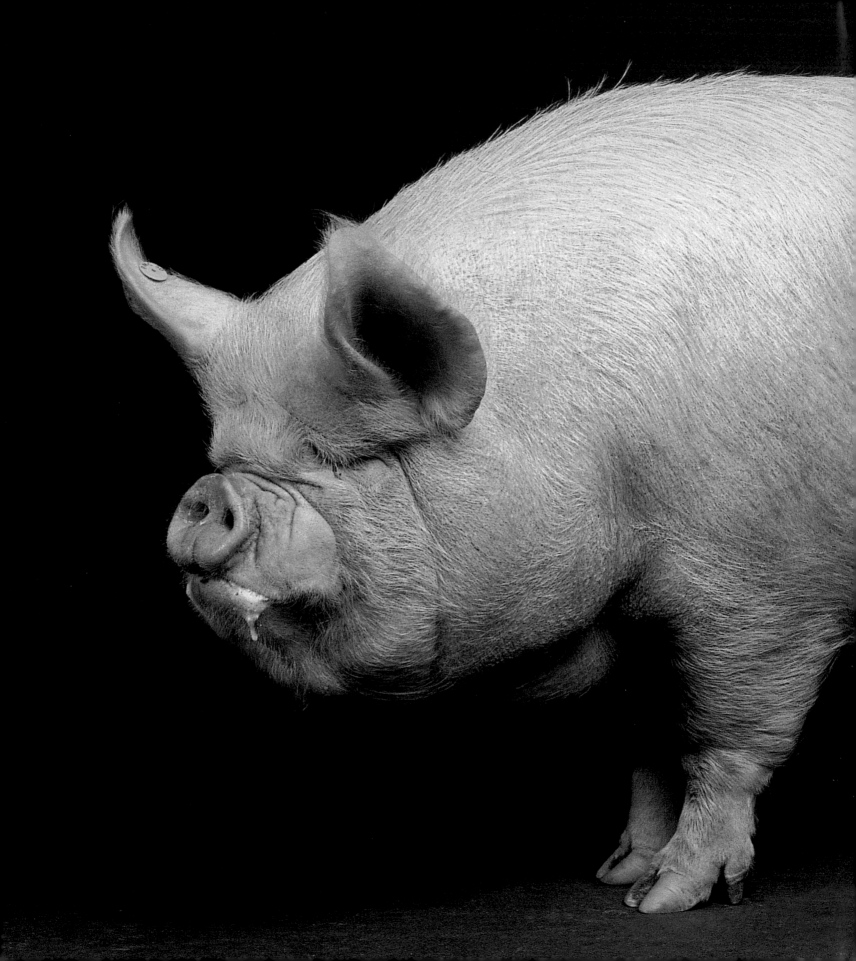

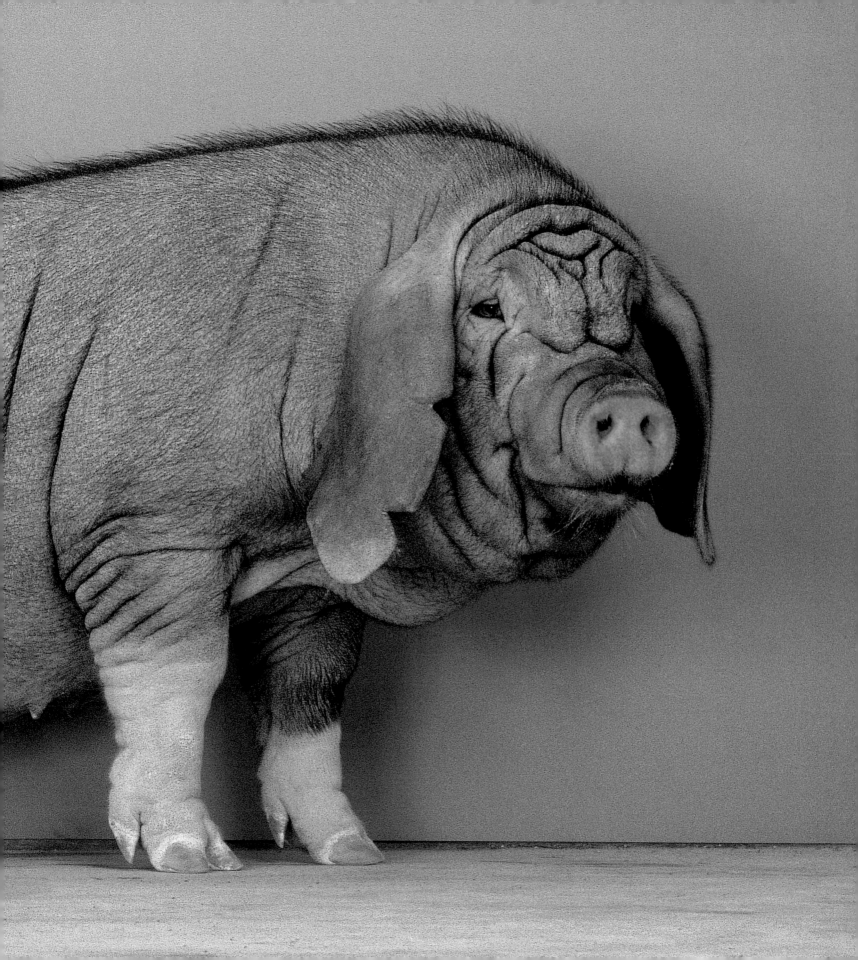

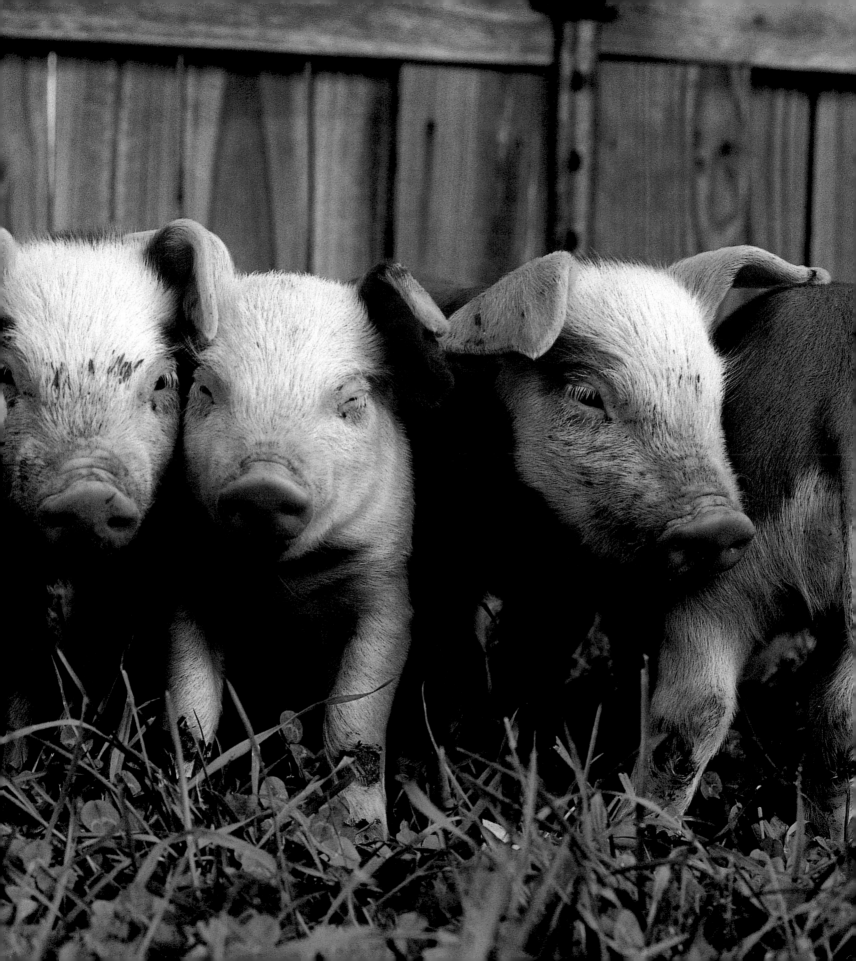

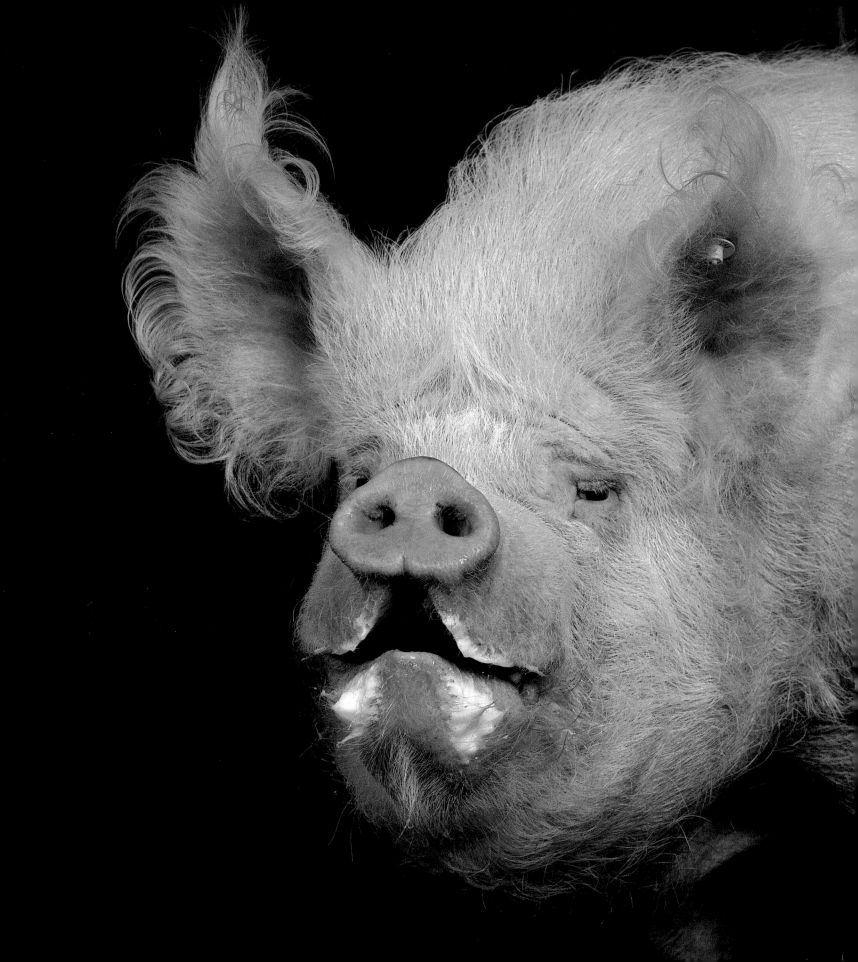

INTRODUCTION

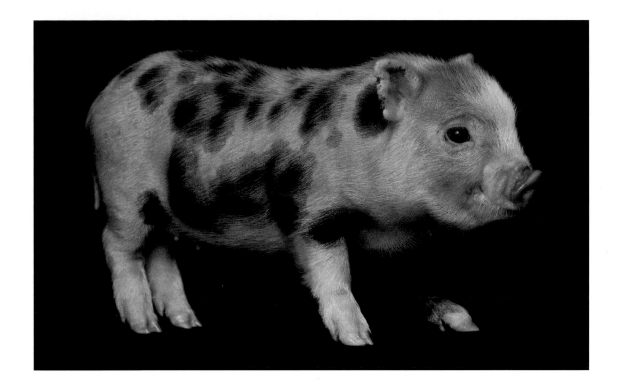

From tiny Kunekunes and wrinkled Meishans to Oxford Sandy and Blacks and curly coated Mangalitzas, there are many more pig breeds than most of us might imagine, and many of them are indeed "extraordinary." As with other livestock species, pigs around the world have been bred to suit regional conditions of climate, landscape, and food supply. They have also been developed to accommodate different tastes in meat, including their suitability for hams, bacons, roasts, chops, sausages, and salamis. Over the centuries, tastes have changed, and pig breeders have adapted.

This book will show not only pig breeds found on farms but also those that are favored as pets. Pigs are intelligent, trainable, clean, and affectionate creatures, making them surprisingly good companions.

In addition, I have included pictures of some wild pig species from Africa and Asia—species that have not been domesticated. These animals are not always recognizable as pigs, and a couple, technically, are not really pigs, but they deserve to be included. The pictures of wild pigs were taken in zoos, but the rest were taken mostly on farms or at agricultural shows.

OPPOSITE: MIDDLE WHITE BOAR, *Westham Mischief 560* or Minty ABOVE: VIETNAMESE POTBELLIED PIGLET

It was not logistically practical to attempt a complete international survey of breeds, and all the pictures here were taken either in England or in the United States. Nevertheless, a great variety of shapes, sizes, colors, patterns, and coat textures was available, and I include breeds from Austria, Belgium, Hungary, New Zealand, China, and Vietnam. So while this volume is not intended as an encyclopedic reference work, it does display a great many wonderful creatures.

I attended two very fine livestock shows: the Royal Show in Warwickshire, England, and the Keystone International Livestock Exposition in Pennsylvania. These shows gave me the opportunity to photograph several different breeds in the same location, all represented by excellent specimens, and all of them groomed to look their best for the judges. I was able to set up makeshift pig portrait studios at these events, which allowed me to take well-lit photographs of my subjects against neutral backgrounds. I also set up my "studio" at certain farms, though at most places I was using natural farm settings. I think the book benefits from the variety.

Taking pig portraits was often quite difficult because most of my subjects were extremely restless. When not sleeping or snoozing, pigs are often on a full-time search for food and are continuously on the move. They are not usually moving briskly, just constantly. This was awkward for me, as I was likely to be lying on the ground in order to shoot my subjects on their level, and often it was hard to adjust my position quickly enough to keep the camera focused on these moving targets.

Readers will notice that the ears of many pigs appear ragged. Individuals can be identified by notches cut into the edges of their ears, and it is also common for them to have a metal or plastic tag attached to one ear. In a few cases, a pig will be seen frothing at the mouth. This does not signal that it is angry, anxious, or sick— it means nothing more than froth at the mouth. The uninitiated may also be surprised to see that some males have large, conspicuous testicles; again, this does not indicate a medical problem—quite the contrary.

Also relatively normal, though unattractive, are the scratches that can be seen on some specimens, most noticeably on the white breeds. These blemishes are usually the result of brief battles at

Keystone International Livestock Exposition, 2009: a Large Black arriving

K.I.L.E., 2009: a Yorkshire being washed

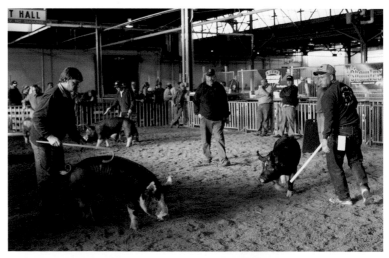

K.I.L.E., 2009: Steve Nichols judging American Berkshires

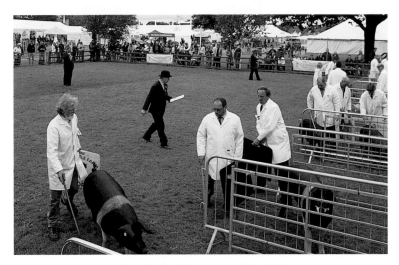

Great Britain's Royal Show, 2009: Judging British Saddlebacks

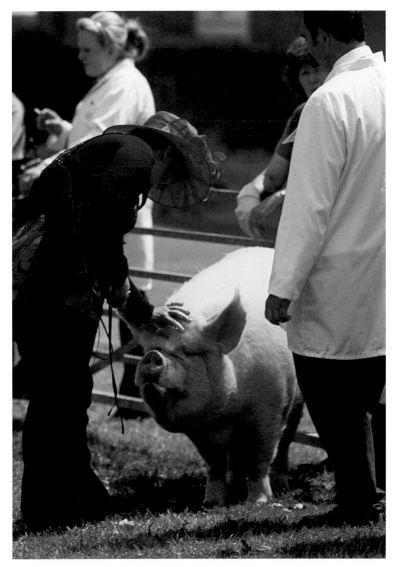

The Royal Show, 2009: Judge Anne Uglow congratulates Alice

home, probably around mealtimes. Pigs are gregarious creatures and like to be around other pigs, but scuffles and brief altercations are not uncommon.

Private farms were usually the only places where I could find rare heritage breeds, some of which have become endangered. When possible, I tried to time my visits to farms to coincide with the presence of a litter of piglets. While some piglets were a little apprehensive about a stranger with a camera, others were full of curiosity, energy, and confidence, often exploring their surroundings like eager puppies.

I tried to record the names and ages of my subjects, but this was not always possible, and in some cases no names existed. Pigs in academic programs sometimes just have numbers. At livestock shows there might be two separate names, one being the formal registered name, the other being a pet name. Most show dogs and show cats are given both a formal name and a much shorter pet name, and it can be the same with pigs.

People unfamiliar with livestock may not know the word "gilt." This is a young female pig that has not yet become a mother, and is roughly the equivalent of a filly, with a sow being the equivalent of a mare. However, the word "boar" covers all males no matter their age. Actually there is an archaic word, "shoat," or "shote," for recently weaned males, but it is no longer used. Slightly confusing is the use of the word "boar" to include both sexes of the Eurasian Wild Boar; so paradoxically, there can be a Wild Boar sow.

"Swine" is usually a collective word, like cattle or poultry, though it can be singular when used as a human insult—"You filthy swine!" "Hog" tends to be used specifically in reference to a pig being raised for meat, often a castrated boar, and often for a pig above a certain weight. It is also part of the name of some wild species, such as the Warthog. Oddly enough, the Red River Hog is very closely related to a species called the Bush Pig, not the Bush Hog. My preference for this book is to use the word "pig."

Work on *Extraordinary Pigs* required the help of a great many people, and on page 111 I will acknowledge and thank them. I hope all will feel good about their efforts when they see how our work has been enhanced by the publisher's editors, designers, and printers.

PRIMITIVE BREEDS

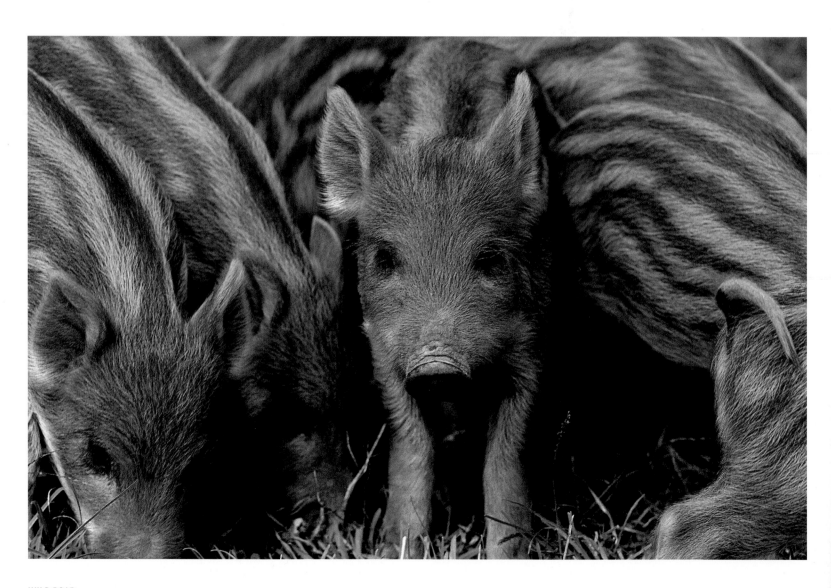

WILD BOAR PIGLETS

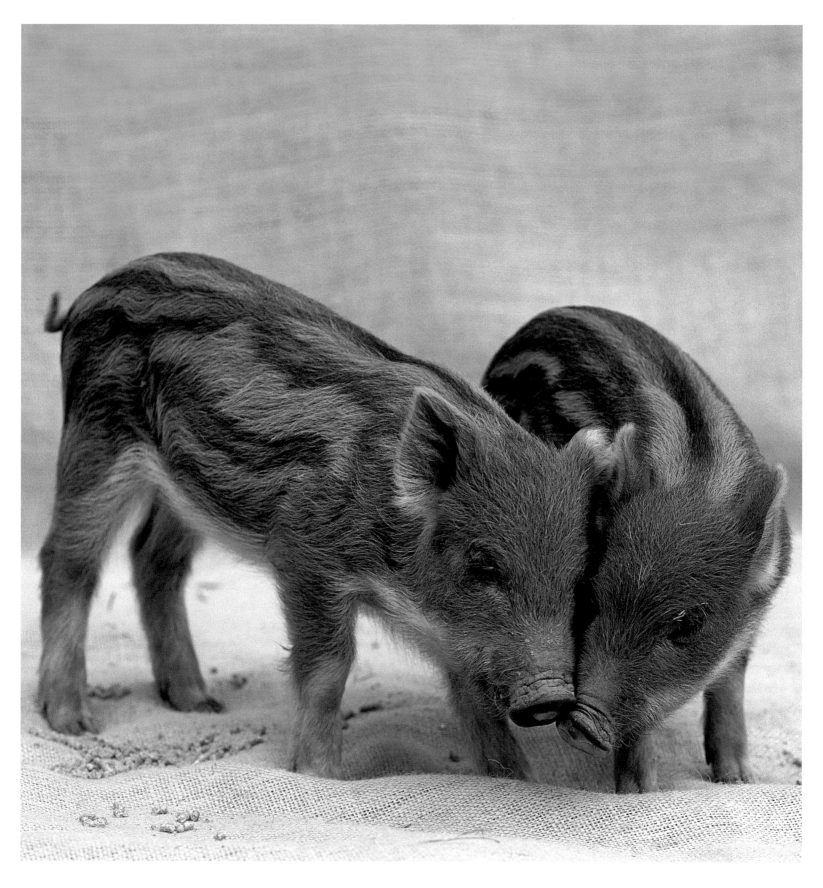

WILD BOAR PIGLETS

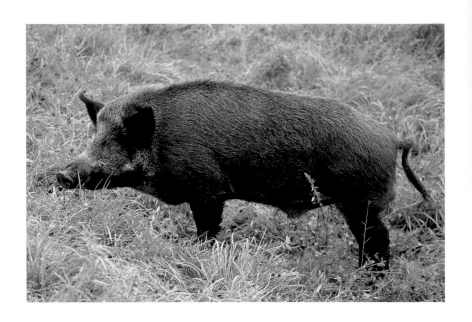

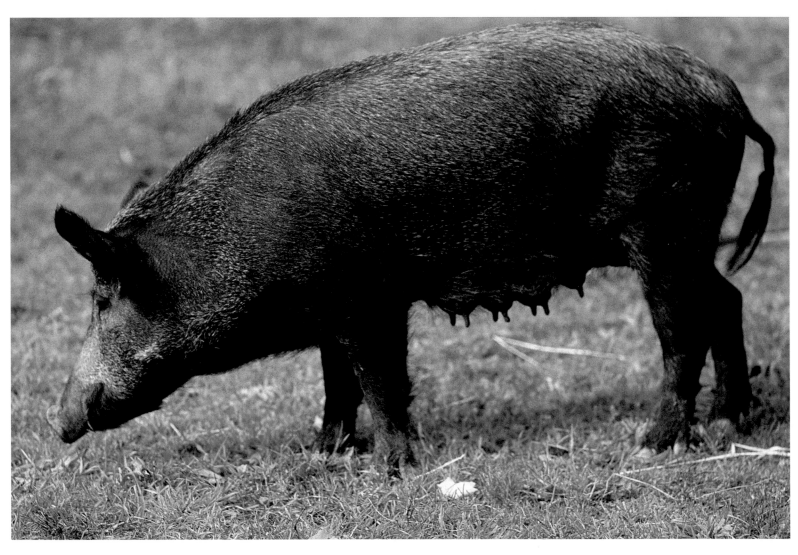

TOP: WILD BOAR BOAR, Harry ABOVE: WILD BOAR SOW, Harriet

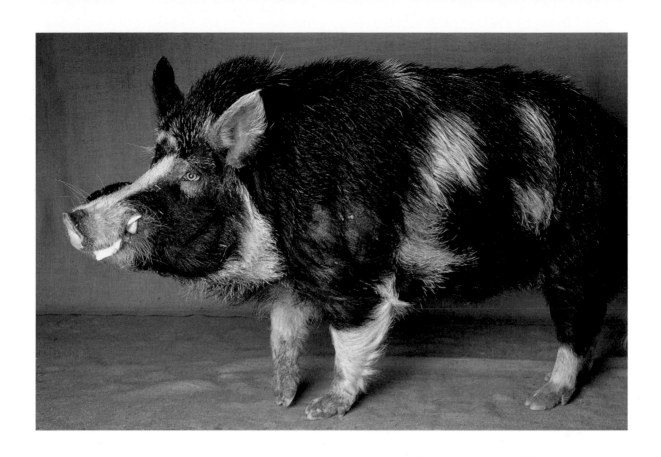

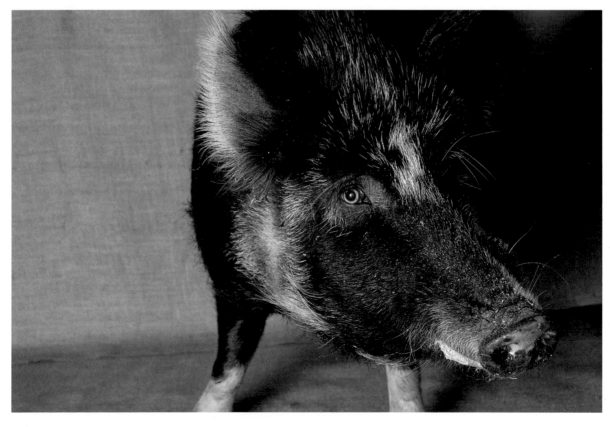

TOP: OSSABAW ISLAND PIG BOAR, Abe ABOVE: OSSABAW ISLAND PIG SOW, Priscilla

Black Breeds

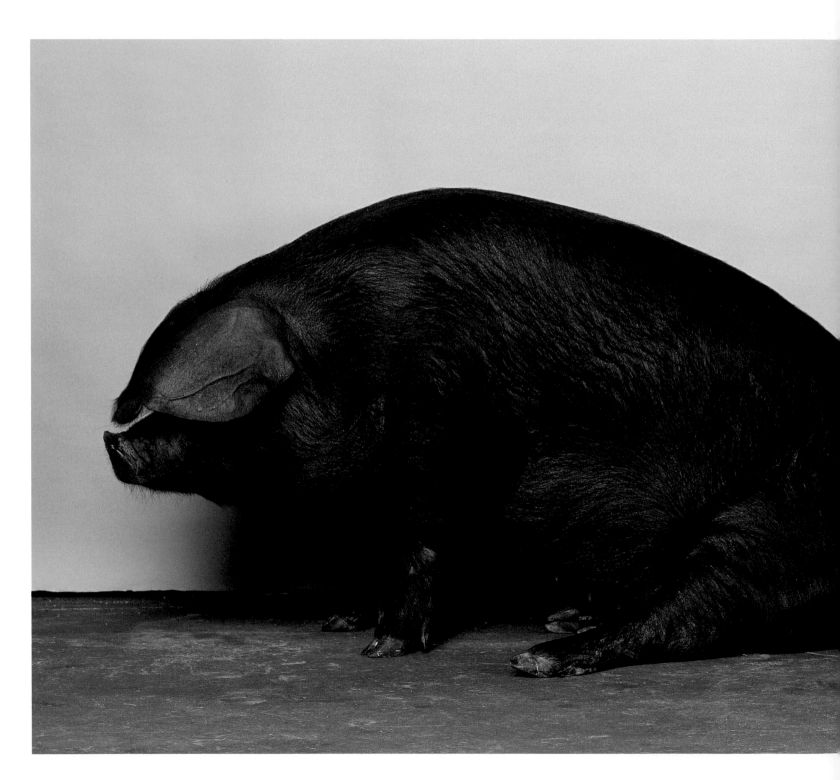

LARGE BLACK SOW, *Sock Doreen 176*

A PIG TRAGEDY IN HAITI

The island of Haiti used to have a very special type of pig. Spanish breeds were originally brought by settlers in the 1500s, and pirates also brought pigs. Over the next five centuries, a type of pig evolved that was not only uniquely suited to the climate, the geography, and the food supplies of the island, but also to the needs of the people. Natural selection had produced the Haiti Creole Pig. It was small but had long legs, was black and slim, energetic, disease resistant, good at scavenging and rooting for food, and able to survive for two or three days without food, if necessary. Pigs became a vital part of the economy of peasant families.

But then, during a period of just thirteen months in 1982 and 1983, the Haiti Creole Pig became totally extinct. The pigs of about 800,000 families were slaughtered, and it cost the American taxpayers $22 million.

Haiti occupied the western half of Hispaniola, while the Dominican Republic occupied the eastern half. In 1978, a number of pigs in the Dominican Republic came down with a disease, and the government asked the United States to help them diagnose it. Unfortunately, the disease was the terrible African swine fever. Fearful that it might spread to other countries, including the United States, the two governments agreed to an eradication program. Farmers were compensated at the rate of $40 per pig.

Haiti's president and dictator at the time was Jean-Claude Duvalier, son of the tyrannical "Papa Doc" Duvalier, and known as "Baby Doc." The greedy, corrupt ruler recognized an opportunity to divert funds and line his pockets if Haiti had a similar program in place, and urged the United States to test his country's pigs. Sure enough, one valley had some cases, but most of these infected Haitian pigs were hardy enough to successfully fight off the effects of this normally fatal fever. The U.S. Department of Agriculture nevertheless went about their grim business of killing all the pigs on the island. People tried to hide their animals, including voodoo priests who insisted that their blood was needed for sacrifices, but the slaughter was relentless. The peasants were devastated. The loss has been estimated at $600 million, but even worse, the peasant way of life was also lost. Even crops suffered since there were no pigs to till the soil with their rooting, or to eat destructive insect pests in the fields. And the world lost forever the genes of an exceptionally disease-resistant animal.

In an attempt to alleviate the loss, the USDA showed continued insensitivity by sending to Haiti American pigs that had been bred for huge commercial hog

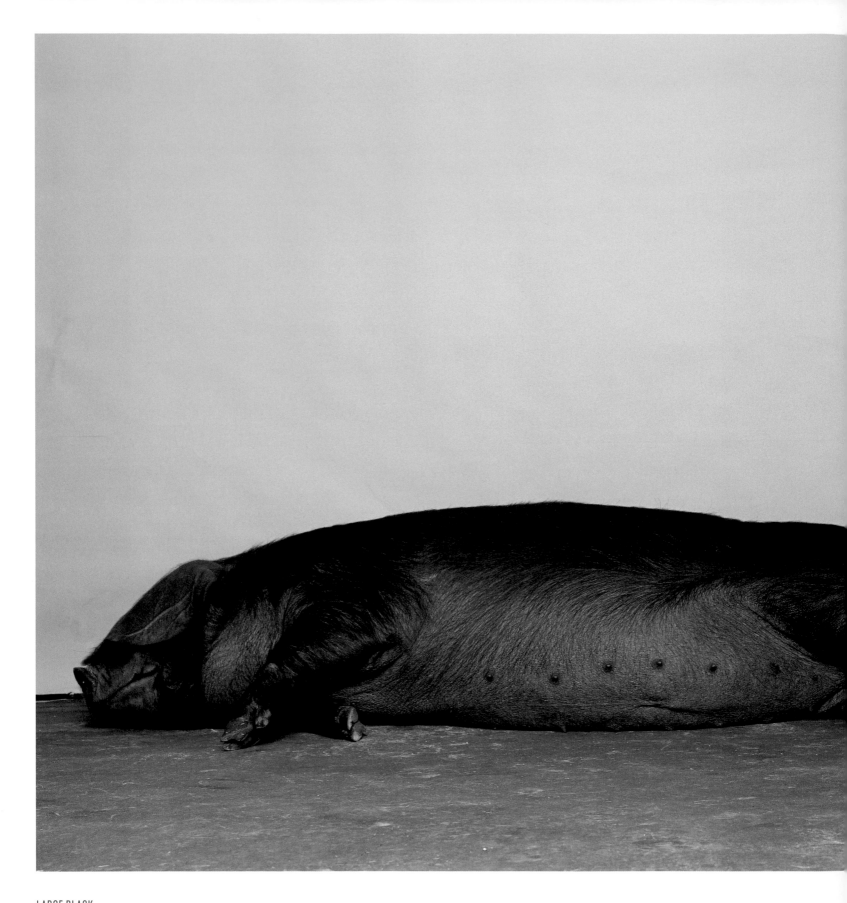

LARGE BLACK SOW, *Sock Doreen 176*

farms, breeds that were not at all adaptable to a tropical climate or to an outdoor life of foraging. To compound this problem, the USDA limited recipients of the pigs to those who could provide shelter, concrete flooring, and feed supplies amounting to $90 per year per pig, more than half the average Haitian income. For the rich families of Haiti, this was fine, and they even accepted the high vet bills for these pampered American pigs. The peasants called the swine "four-legged princes."

Meanwhile, in 1985 French scientists from the National Institute of Agronomic Research were working on a much more viable solution. Guadeloupe, another French-speaking Caribbean island, had evolved its own Creole pig. The experts crossed these with a hardy breed from Gascony in Southern France, a breed probably related to the Iberian pigs that had crossed the Atlantic centuries earlier. Some genes were added from Chinese pigs, the Meishans, which are noted for their large litters, good for quickly repopulating a country. But Duvalier and his supporters would not allow the import of these hybrids, since the elite were enjoying the exclusivity of their pig ownership and were happy to have removed this element of economic independence from the peasant classes.

Fortunately, when Duvalier's rule was over in 1986 and revolutionary forces chased him into exile, the new French pigs were allowed to start repopulating the island. They were joined by some fine black pigs from the Lesser Antilles, and some even mated with the American pigs. The population grew quickly.

In early 2008 there was another promising import. Some rare Large Blacks from Wolfe Mountain Farms were sent to the island to begin a breeding program. This is a pig that likes to live outdoors and has done well in climates like Haiti's. Litters have been raised successfully in spite of the chaos of Haiti's destructive earthquake in 2010. A new pig population has started to grow.

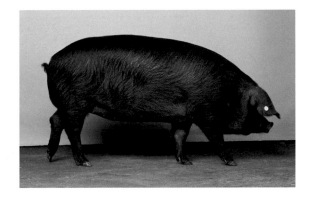

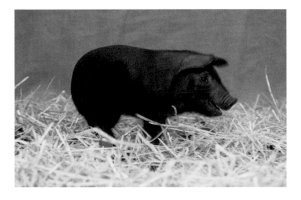

LARGE BLACK SOW, *Sock Doreen 176*

ONE-WEEK-OLD LARGE BLACK PIGLET

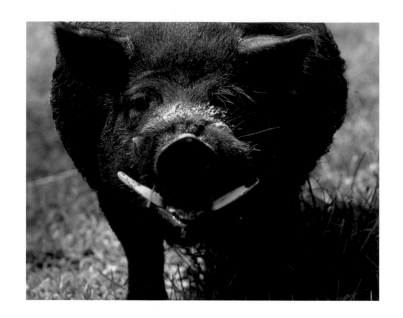 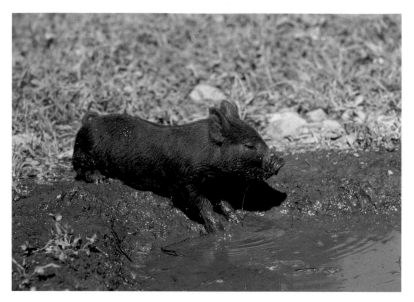

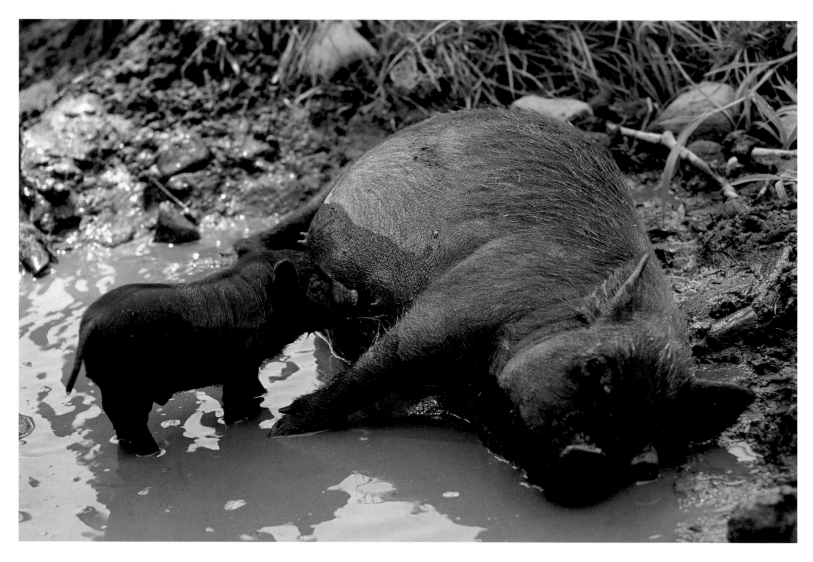

TOP LEFT: GUINEA HOG BOAR, *Brothers CG or George* TOP RIGHT: GUINEA HOG PIGLET ABOVE: GUINEA HOG PIGLET AND SOW, *Sullbar Lilith*

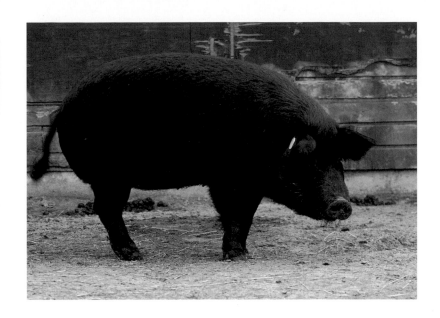

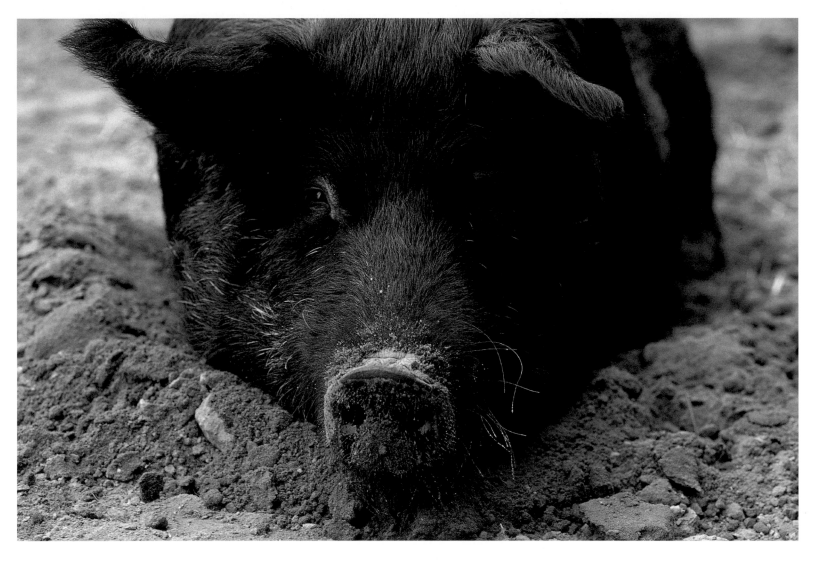

TOP LEFT: MULEFOOT GILT, Clem TOP RIGHT: MULEFOOT HOOVES ABOVE: MULEFOOT SOW, Dottie

MINIATURE PIGS

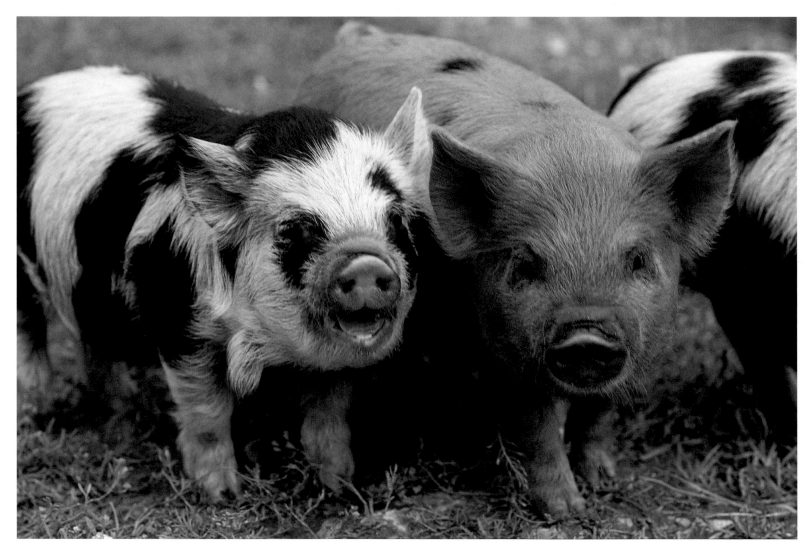

TOP: SIX-WEEK-OLD **KUNEKUNE** PIGLETS ABOVE: SIX-WEEK-OLD **KUNEKUNE** PIGLETS

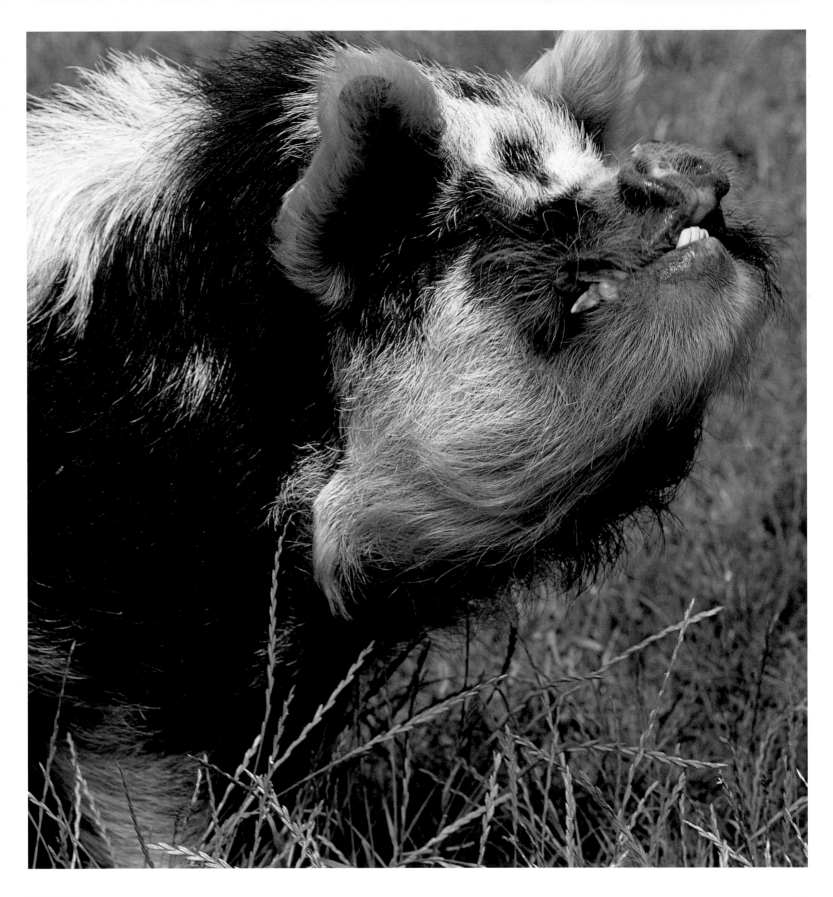

KUNEKUNE BOAR, *Long Ash Andrew 884* or Nobby

TOP: FOUR-MONTH-OLD **KUNEKUNES,** *Pumpkin Tutaki* (left) and *Pumpkin Sally* ABOVE: SEVEN-MONTH-OLD **KUNEKUNE,** *Ryall's Sally 9th*

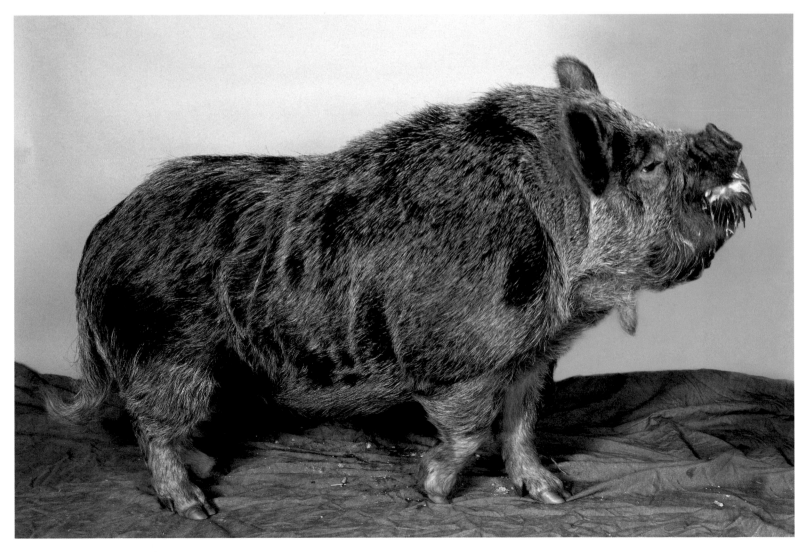

TOP: PENNYWELL MINIATURE PIGLETS ABOVE: PENNYWELL MINIATURE BOAR, Pumba OVERLEAF: PENNYWELL MINIATURE SOW, Matilda, WITH PIGLETS

29

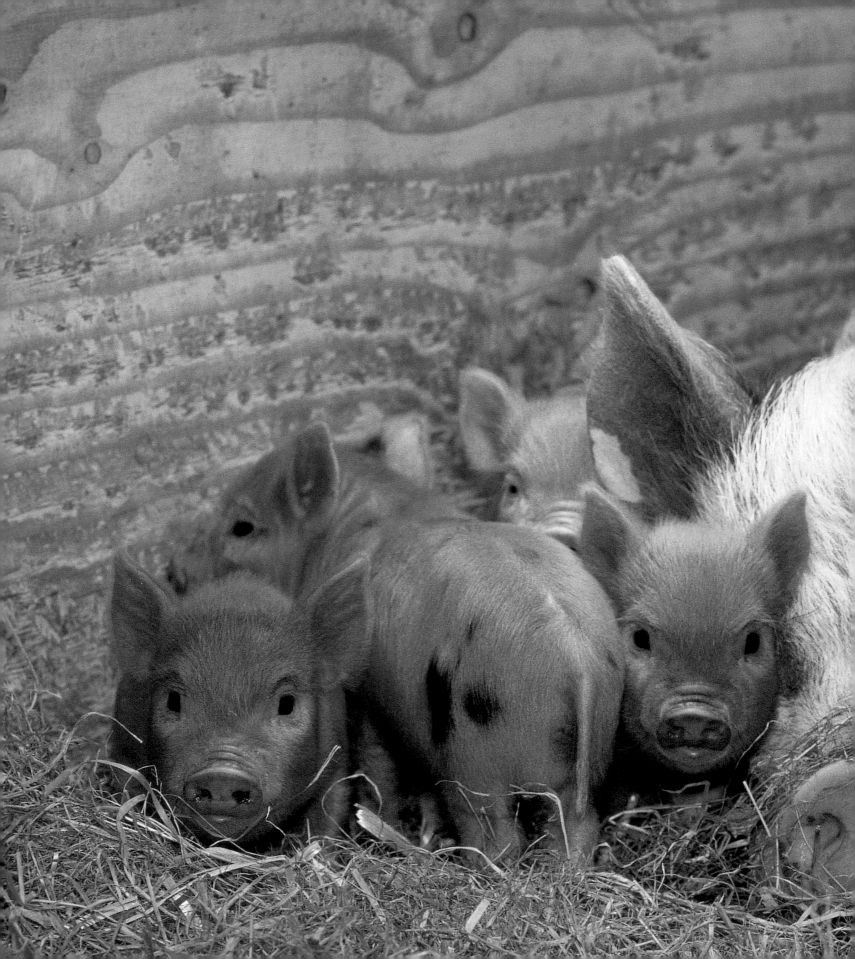

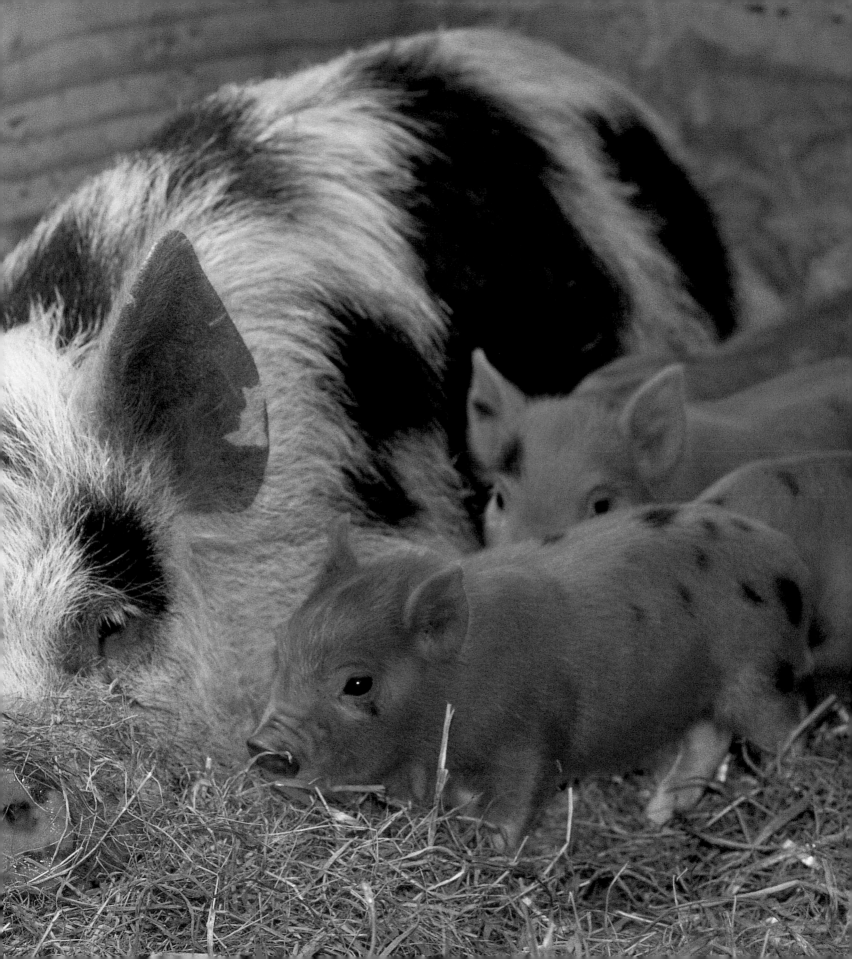

WHITE BREEDS WITH PRICK EARS

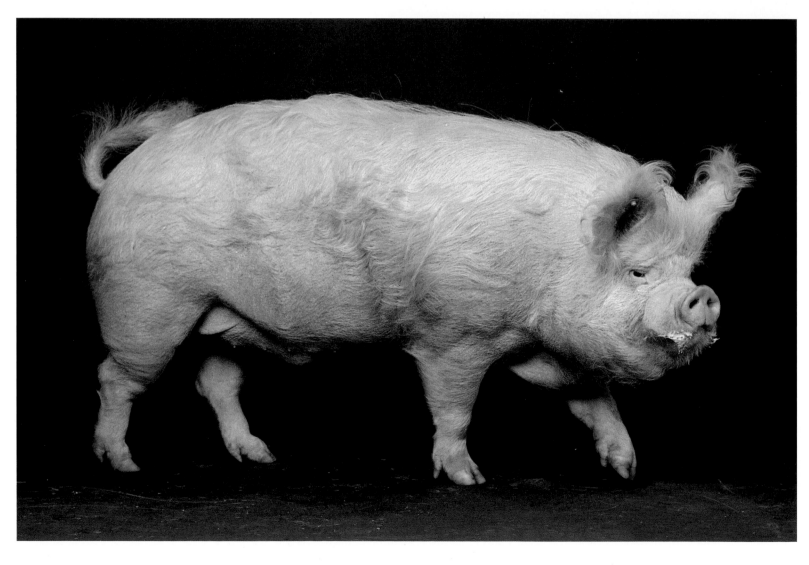

TOP: **MIDDLE WHITE** SOW, *Lewin Dorothy 3* or Alice ABOVE: **MIDDLE WHITE** BOAR, *Westham Mischief 560* or Minty

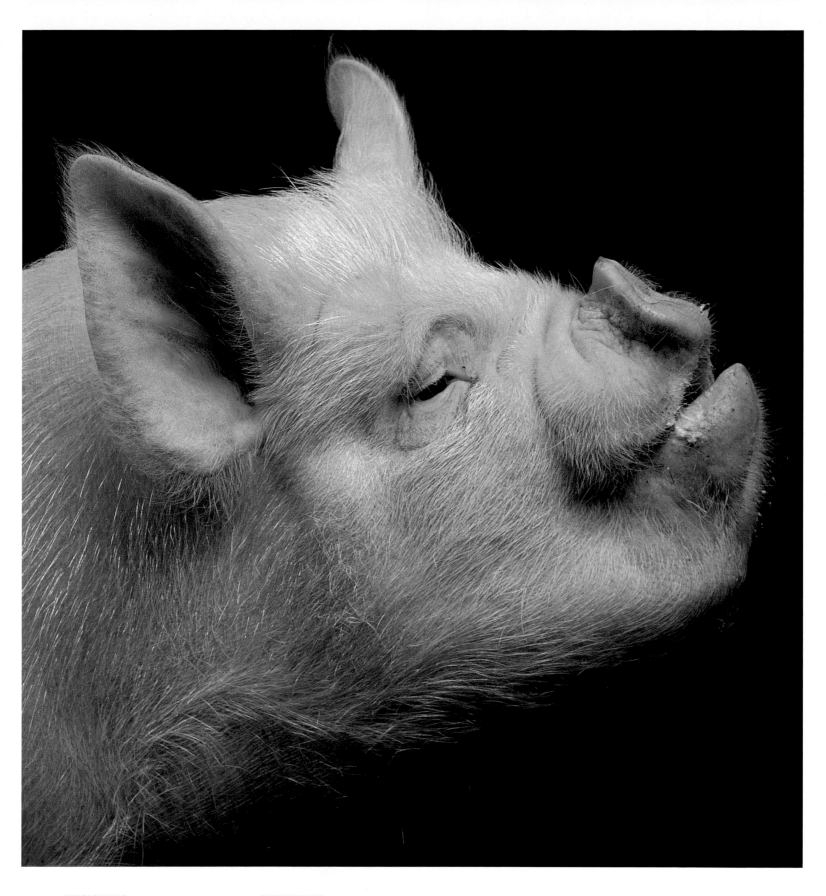

ABOVE: MIDDLE WHITE BOAR, Cassidy OVERLEAF: MIDDLE WHITE PIGLETS

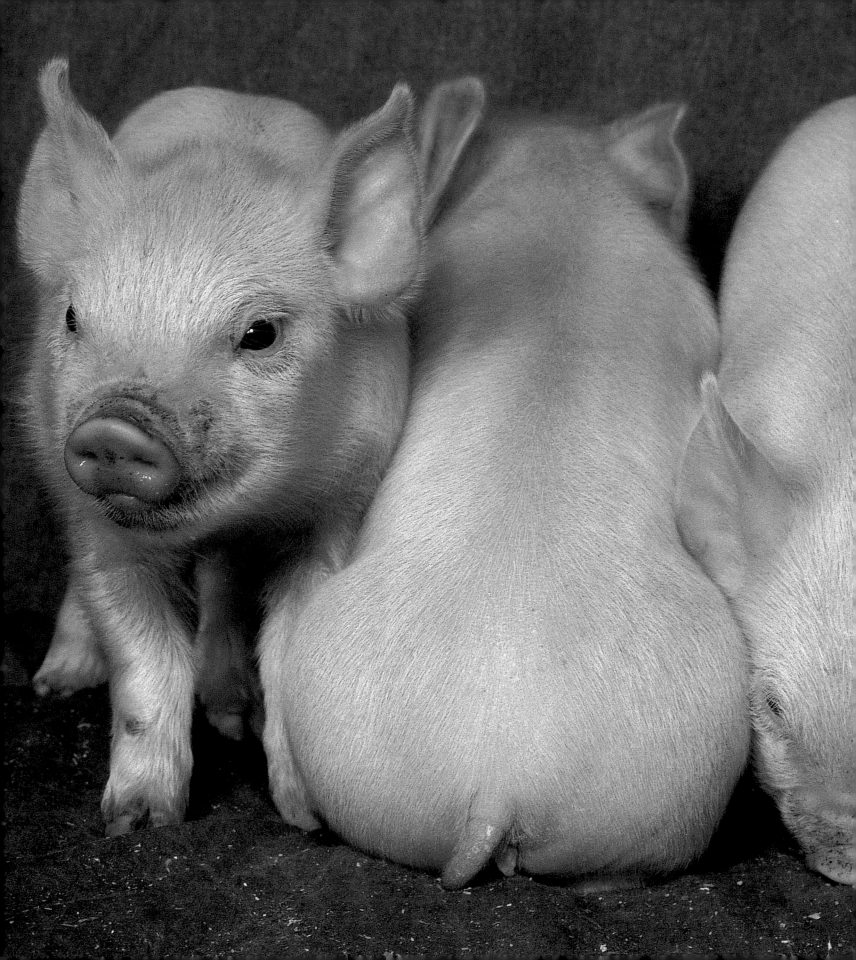

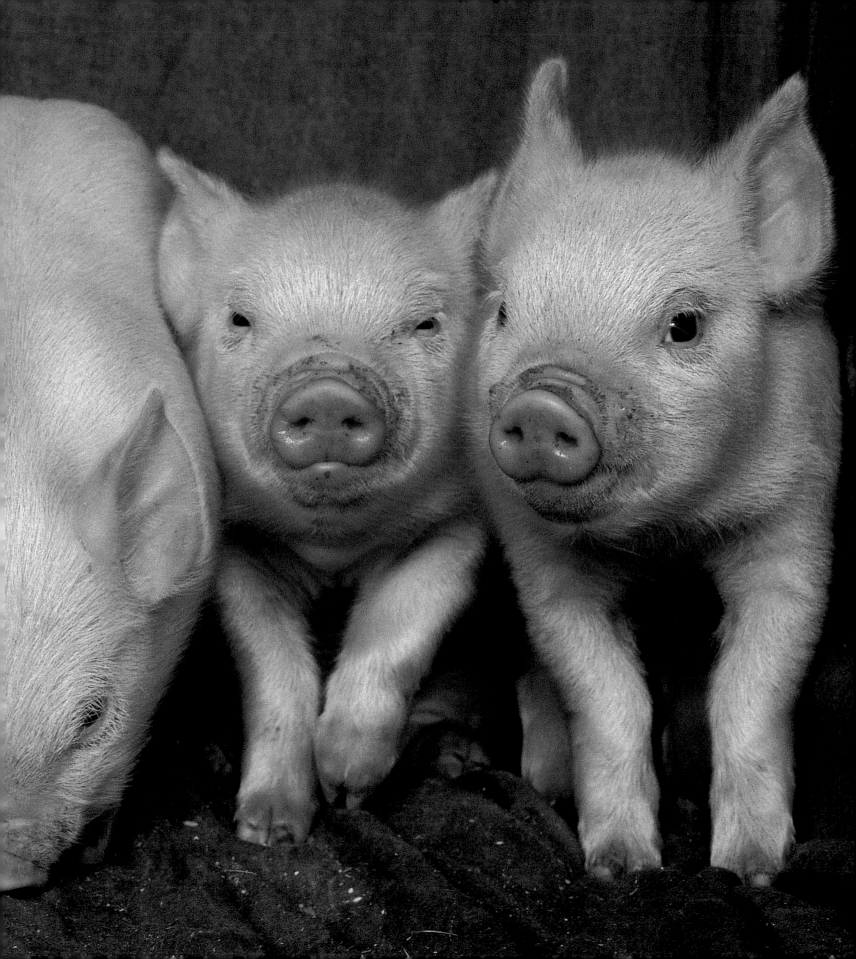

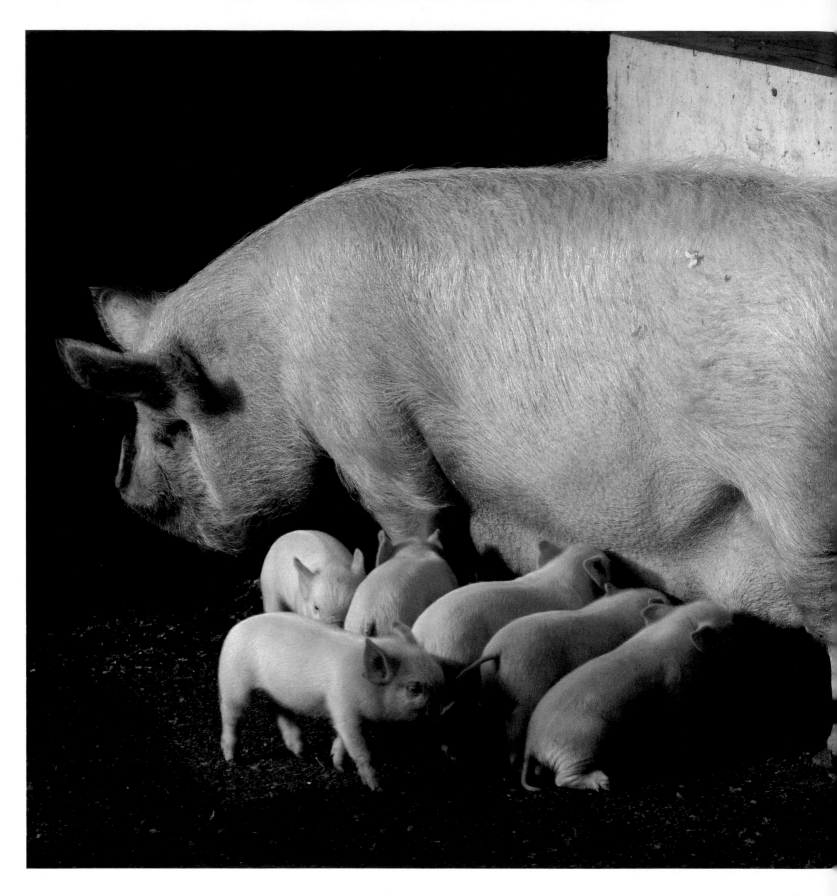

MIDDLE WHITE PIGLETS WITH SOW, *Gracebank Yootha 10* or Flo

CHURCHILL'S TRADE

One of Winston Churchill's friends was Lord Rootes, who was the owner of the Rootes Group, a British car company that manufactured four makes. The top of the line was the Humber, a large car that was not the equal of a Rolls-Royce but was nevertheless prestigious. Lord Rootes would occasionally visit the prime minister at Chartwell, Churchill's country estate.

On one of these visits, Lord Rootes arrived in a brand-new Humber estate. Winston admired it and very much wanted one for himself. He proposed a trade: In exchange for a Humber, Lord Rootes might receive several of Churchill's beloved pigs, his Large Whites. One wonders, was this a case of the gentleman farmer valuing his precious pigs so highly, or did his guest feel pressure to submit unwillingly to the offer of his very persuasive prime minister?

As it turns out, Lord Rootes actually had a farm, on which he raised prize-winning cattle, so he was in a position to take delivery of Winston's pigs if he accepted the trade. An elderly man familiar with the Rootes farm has confirmed that there had indeed been Large Whites there at one time. So it seems that the prime minister received his Humber!

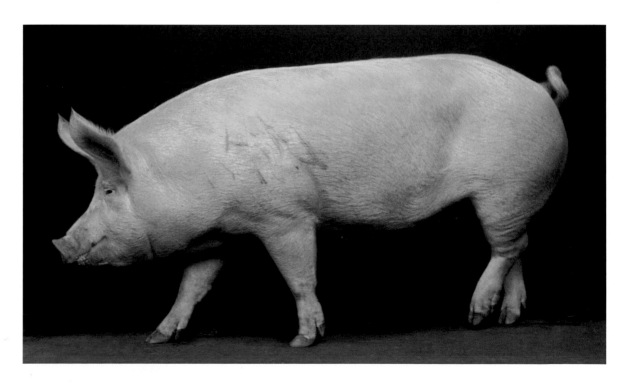

ABOVE: LARGE WHITE GILT, *Hayley Loveless* OVERLEAF: YORKSHIRE BOAR, *Bulletproof*

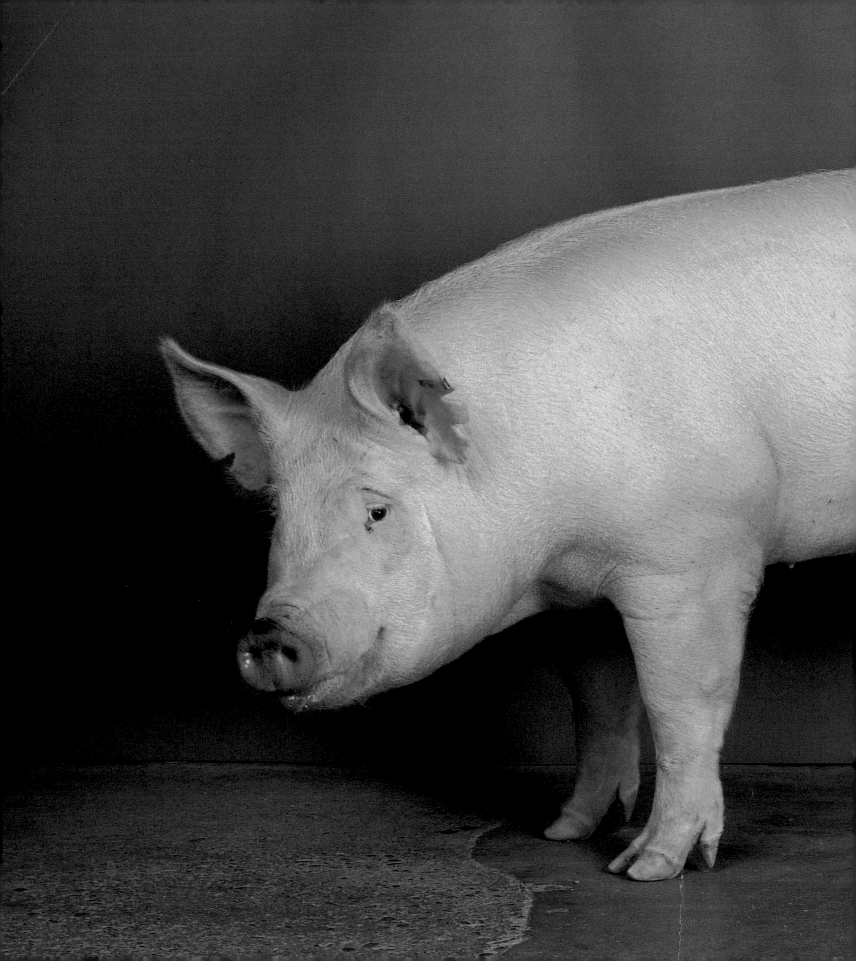

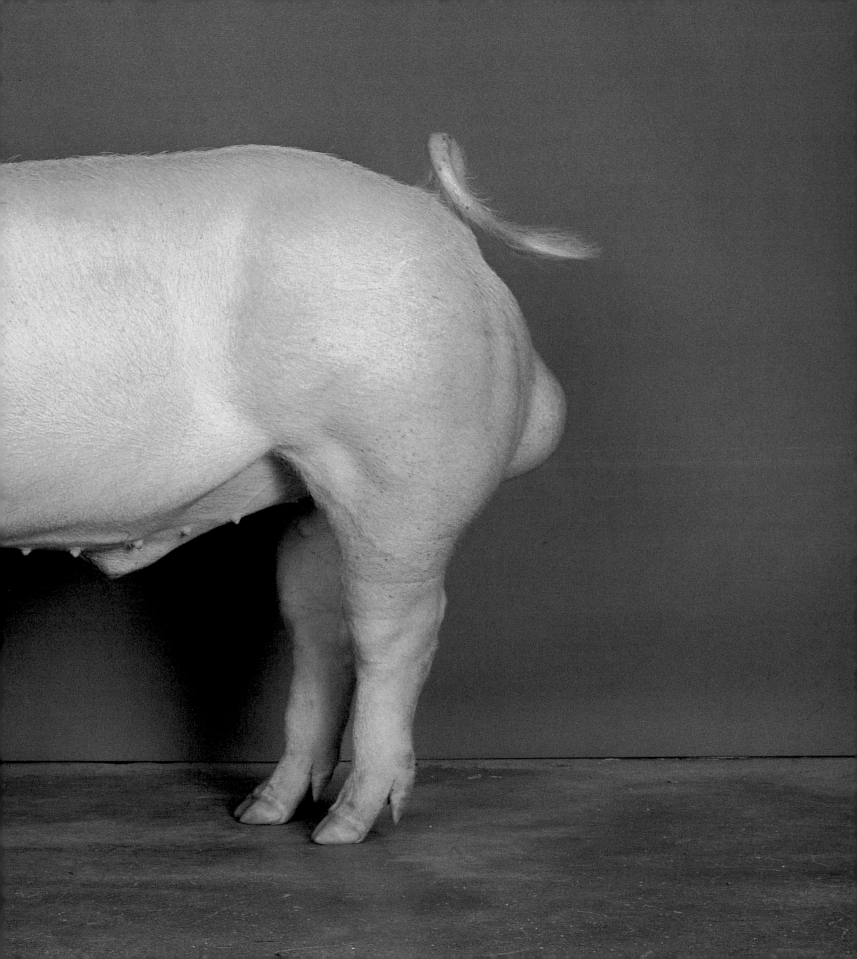

BELTED

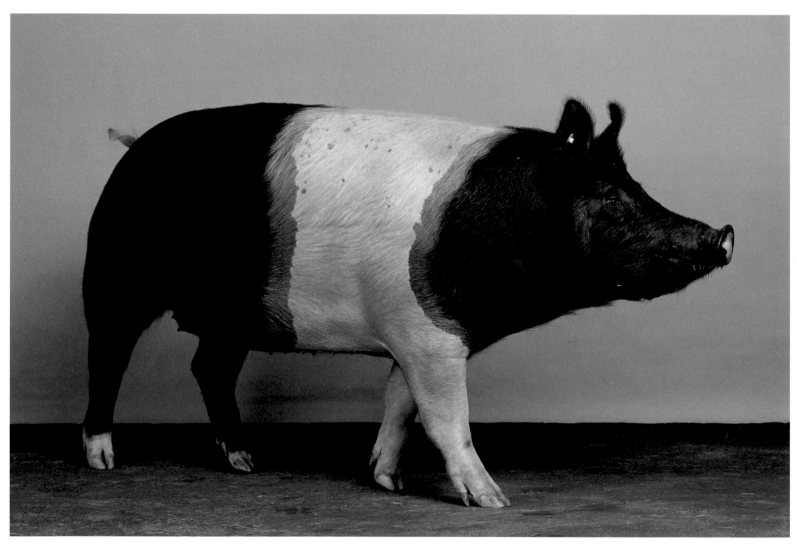

TOP: **BRITISH SADDLEBACK** BOAR, *Heytsbury Viscount 64* ABOVE: **HAMPSHIRE** GILT, *Balsham Princess 4*

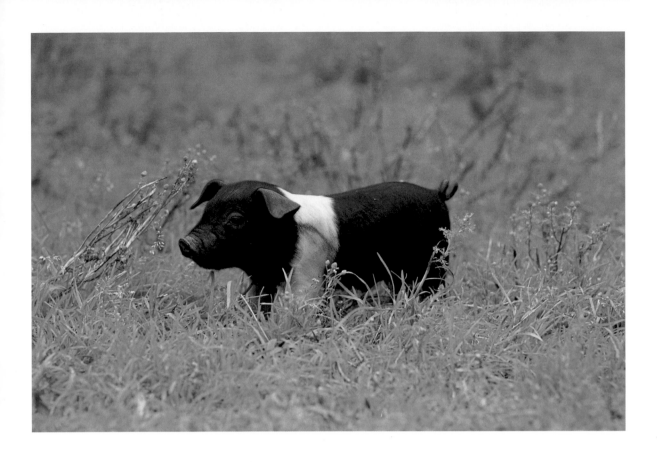

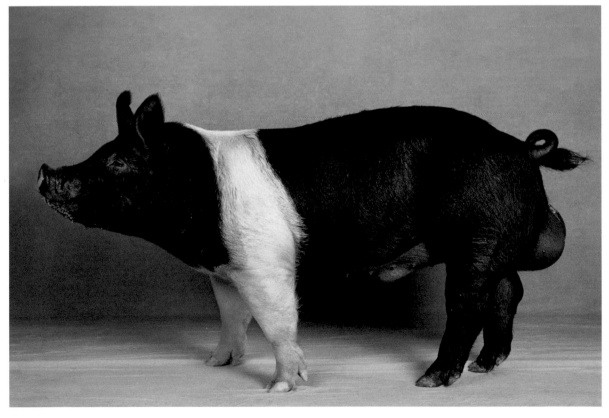

TOP: BRITISH SADDLEBACK PIGLET ABOVE: HAMPSHIRE BOAR, *Ramy9 Sinbad 9-3*

ASIAN BREEDS

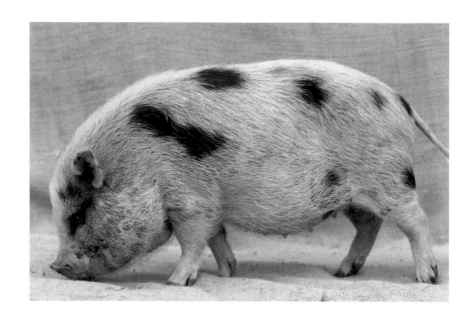

TOP: YOUNG VIETNAMESE POTBELLIED ABOVE: YOUNG VIETNAMESE POTBELLIED

GRANDMA

Patsy, a Vietnamese Potbellied pig, was so named because she had been born on St. Patrick's Day. She was an elderly spinster sow, and in spite of her never having had offspring, she was affectionately known as Grandma.

When the other breeding sows living in this private residence were weaning their piglets, the withdrawal of milk privileges was gradual and accompanied by loud complaints as the teats were denied to the piglets. At this point they would turn to old Grandma, who, recognizing their need, would roll over to expose her teats to the desperate little piglets. Obviously there was no milk, but the youngsters took comfort in the familiar experience. They had accepted the offer of what's called a pacifier (known as a dummy in Britain)—in fact, a whole row of pacifiers. Patsy would then take on the role of parent, and visitors to the house would assume that this wrinkled old creature was indeed the mother.

VIETNAMESE POTBELLIED BOAR, Franklin

VIETNAMESE POTBELLIED SOW, Nonni Mina

VIETNAMESE POTBELLIED SOW, Patsy or Grandma

ONE-WEEK-OLD VIETNAMESE POTBELLIED PIGLETS

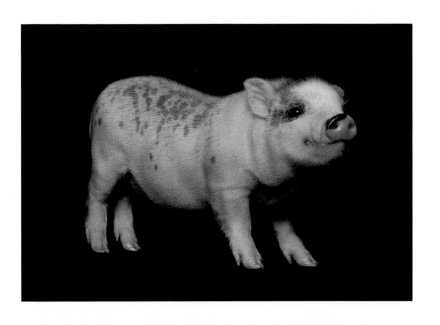

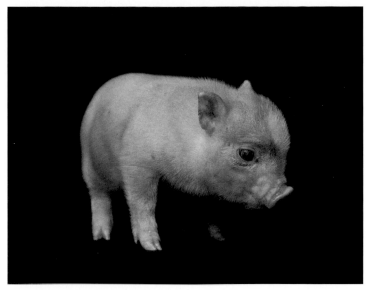

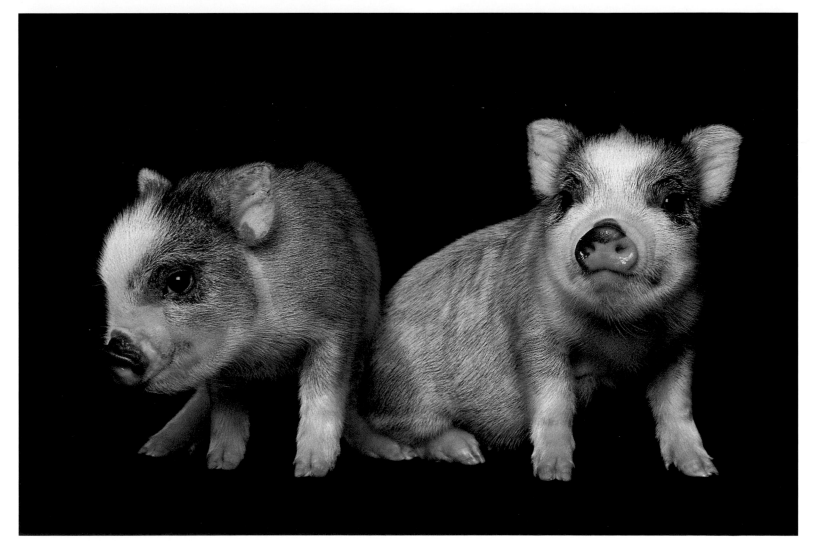

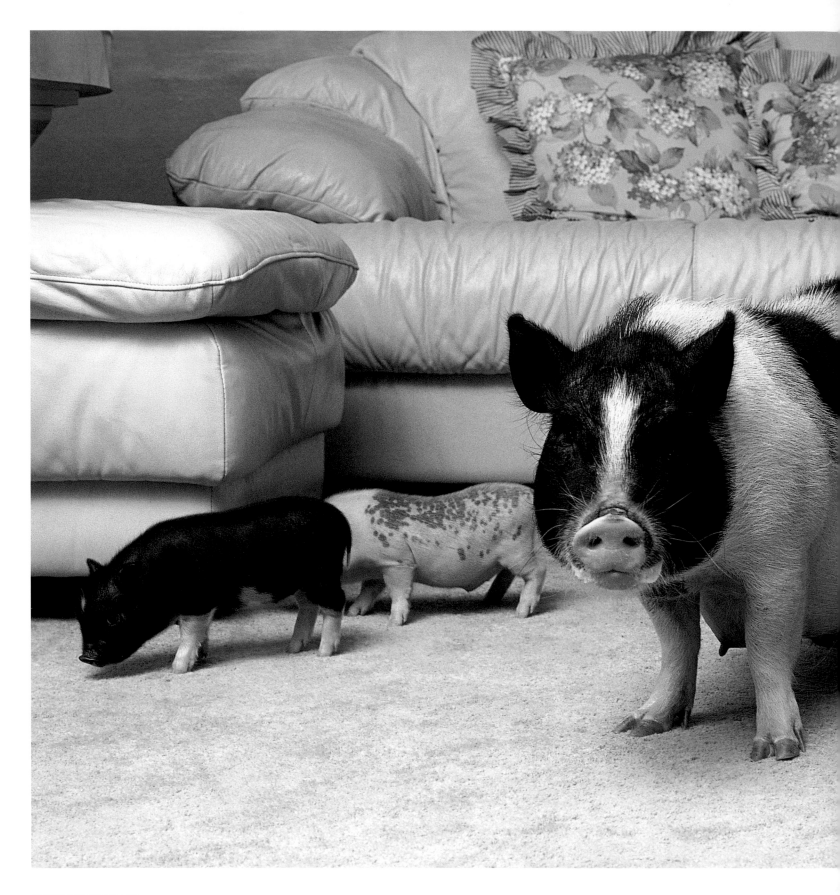

VIETNAMESE POTBELLIED PIGLETS AND SOW, Mimi

THE NEST

A pregnant Vietnamese Potbellied sow was living in a barn adjacent to a flower garden, both within sight of the owner's house. Though the due date was not certain, it did not seem imminent, and the barn would be a comfortable place to give birth when the time came. Then early one morning, the owner looked out of her window to a puzzling sight. A long row of white impatiens flowers had totally disappeared. Hearing some sounds outside her field of vision, she investigated, and came upon her sow with a litter of new piglets, all lying in the middle of a perfectly round circle of white flowers. Somehow the mother had found her way out of the barn, spent the night collecting hundreds of flowers, presumably one by one, carrying them to the nest site, carefully arranging them in a circle, all while in the most advanced state of pregnancy possible, and all in total darkness. Then she had delivered her family in this lovely nest. As Charlotte the spider might say, "Some Pig."

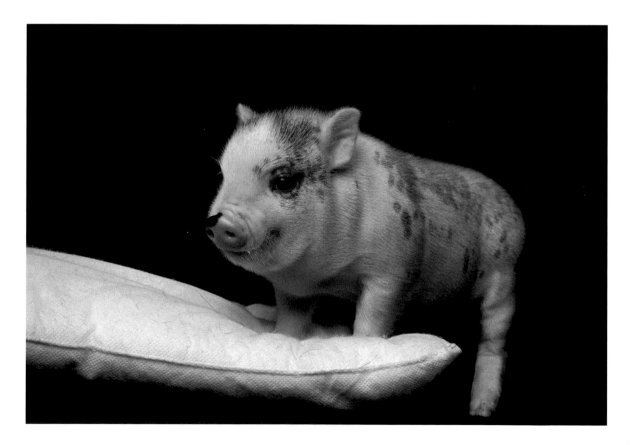

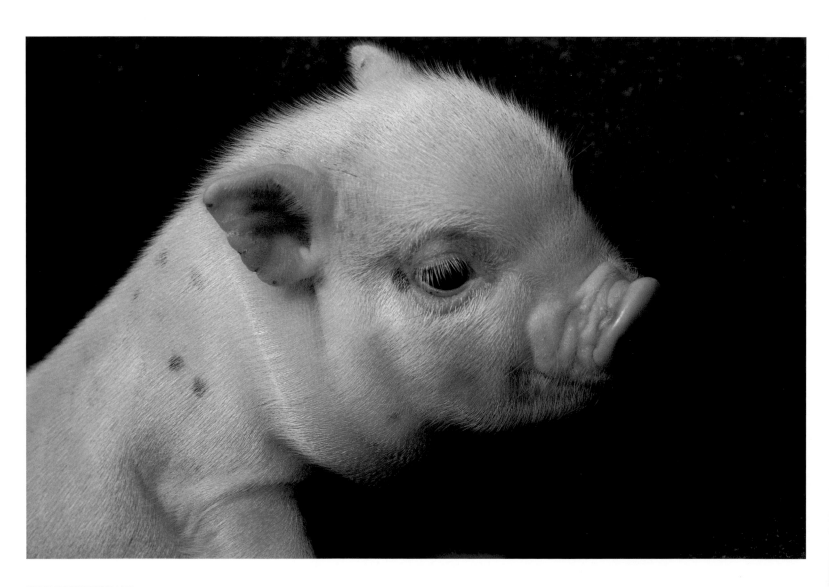

VIETNAMESE POTBELLIED PIGLET

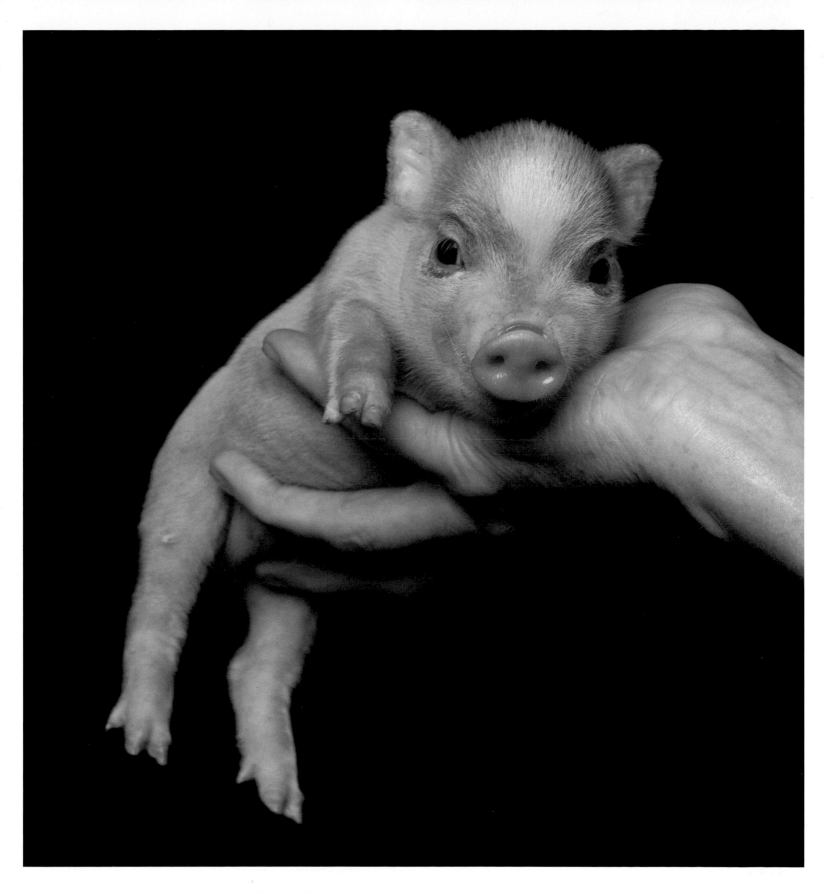

ABOVE: VIETNAMESE POTBELLIED PIGLET OVERLEAF: VIETNAMESE POTBELLIED PIGLETS

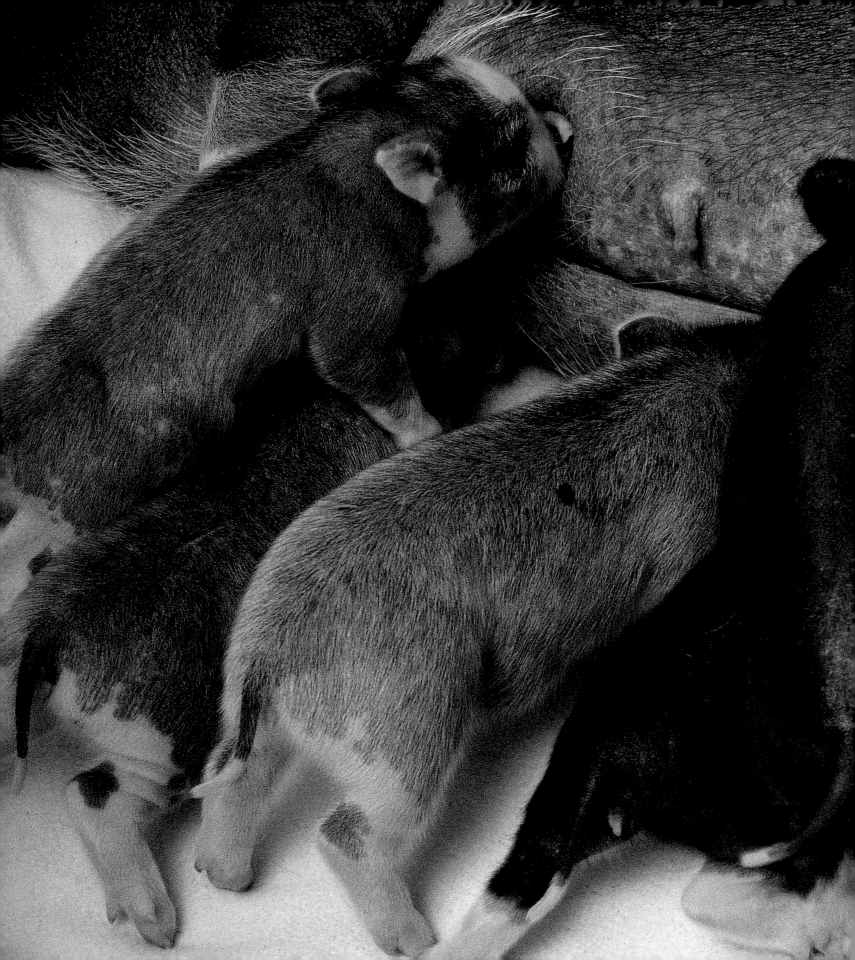

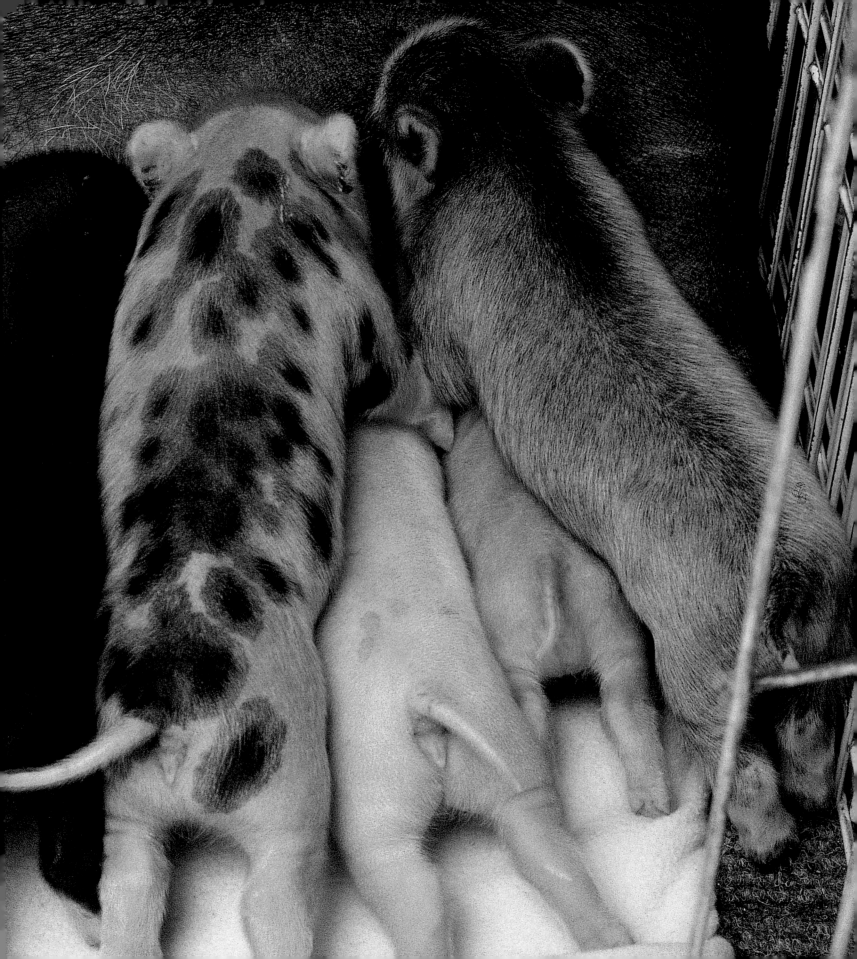

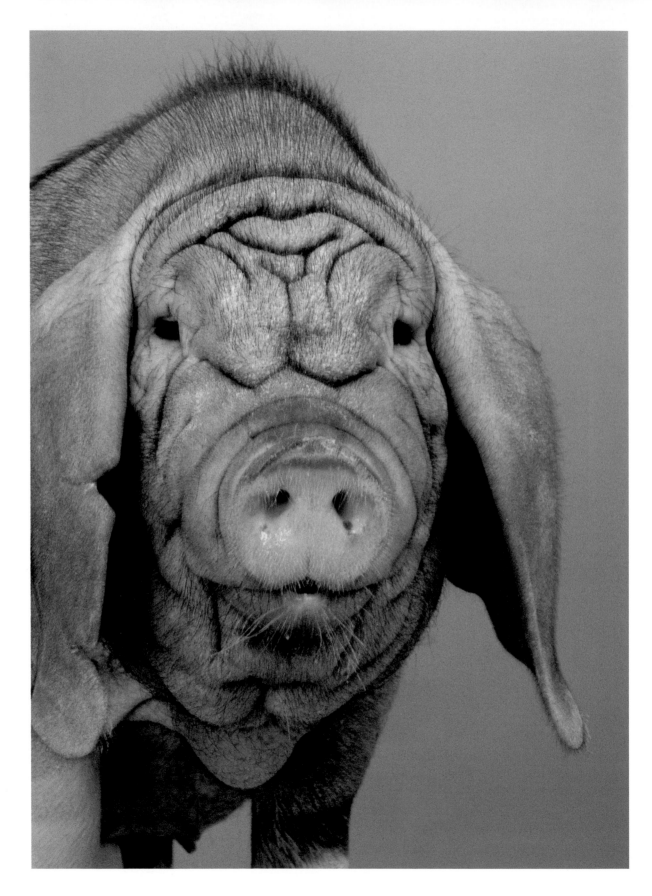

MEISHAN GILT, *4001*

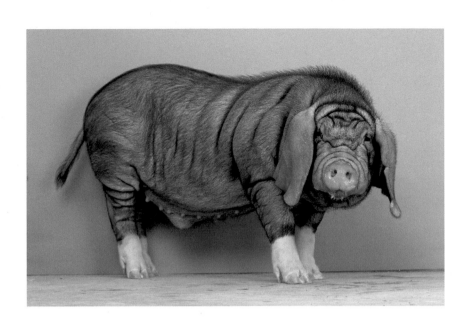

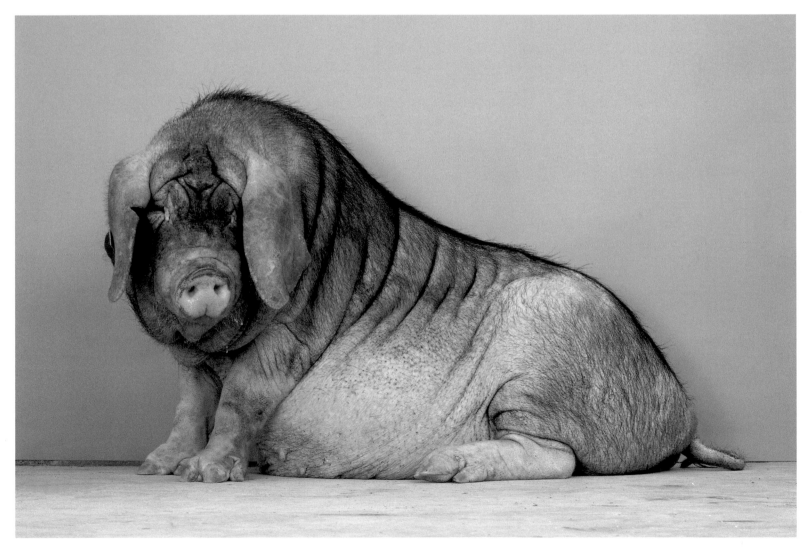

TOP: MEISHAN BOAR, *4000* ABOVE: MEISHAN SOW, *154*

TWO-WEEK-OLD YORKSHIRE/MEISHAN CROSSES

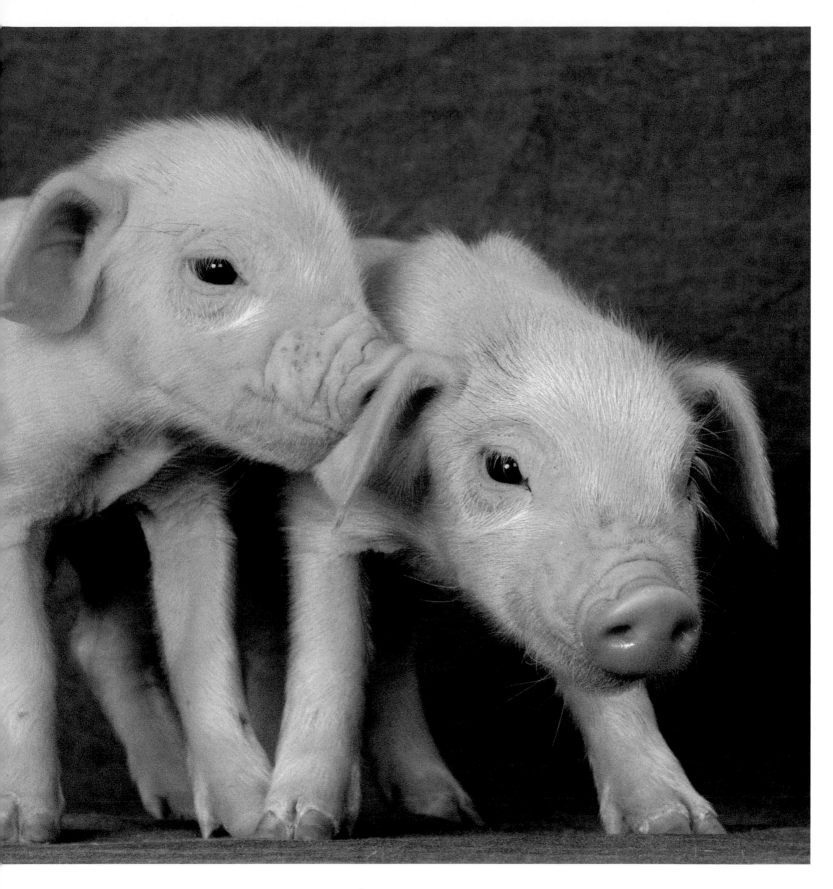

FOUR-DAY-OLD YORKSHIRE/MEISHAN CROSSES

BLACK WITH WHITE POINTS

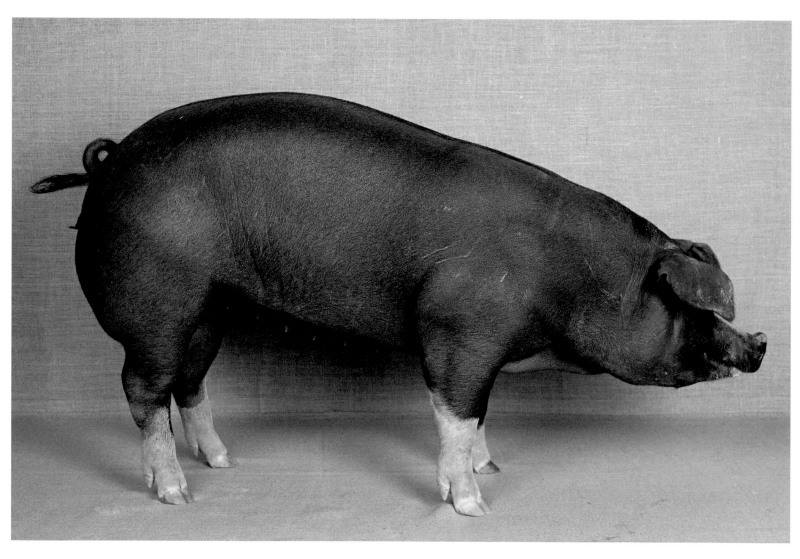

TOP: TYPICAL BERKSHIRE TAIL ABOVE: POLAND CHINA GILT, *Bling America*

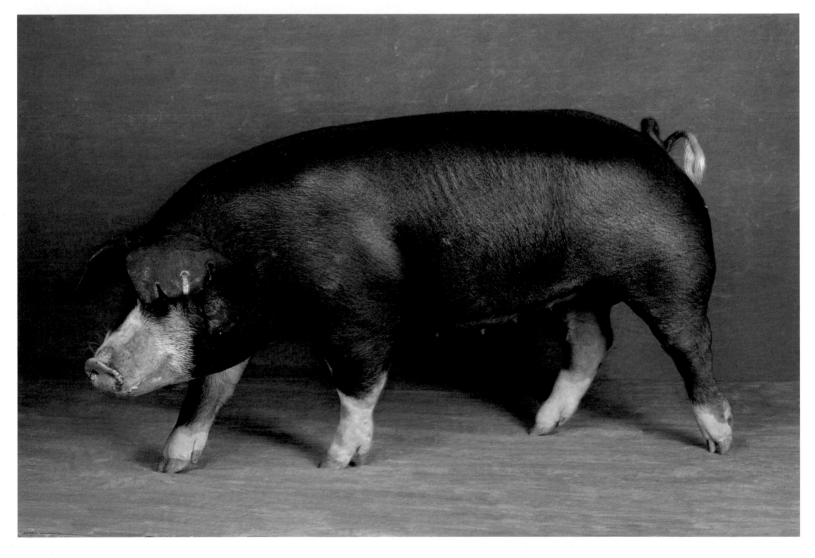

TOP: TWO-WEEK-OLD AMERICAN BERKSHIRE PIGLET ABOVE: AMERICAN BERKSHIRE GILT

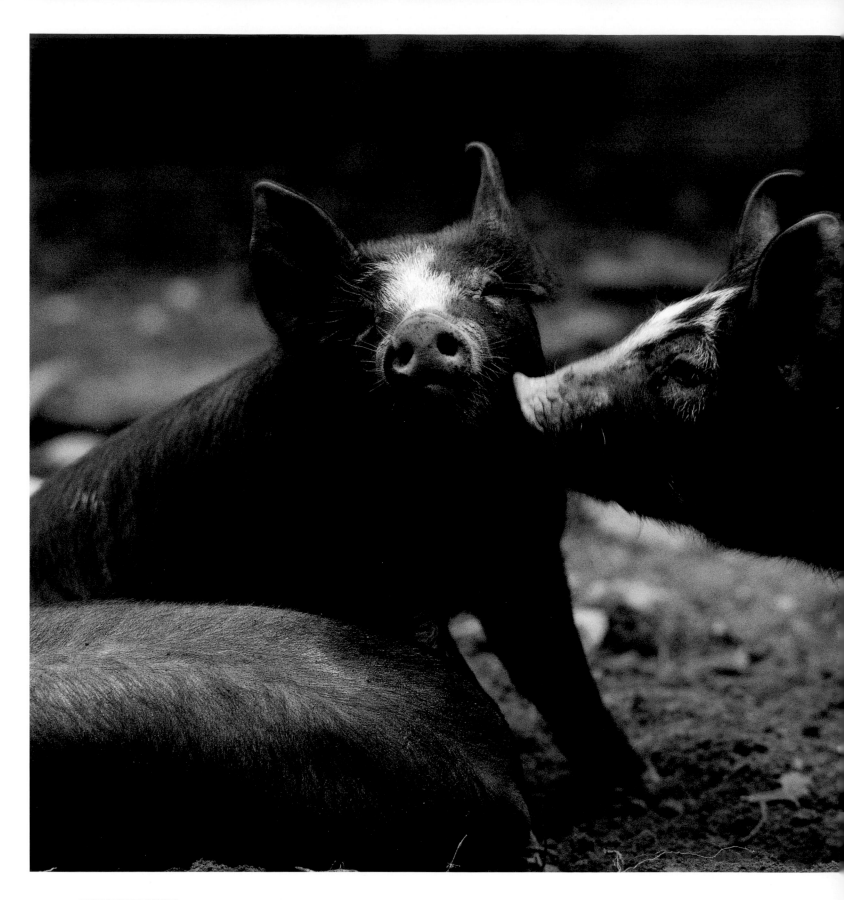

SIX-WEEK-OLD AMERICAN BERKSHIRES

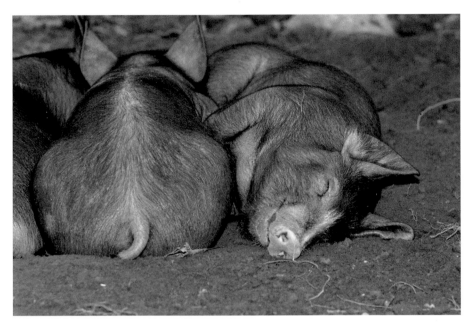

THREE-MONTH-OLD AMERICAN BERKSHIRES

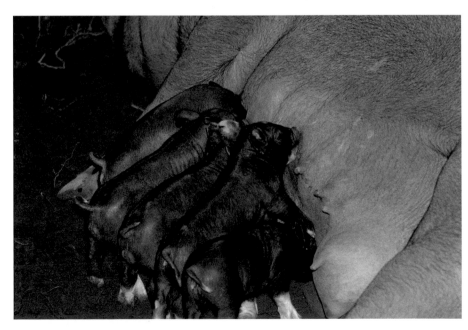

TWO-WEEK-OLD AMERICAN BERKSHIRE PIGLETS WITH SOW

COLORED BREEDS

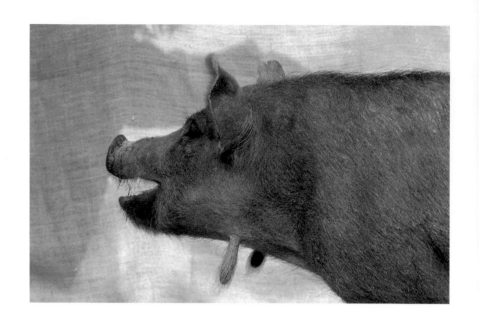

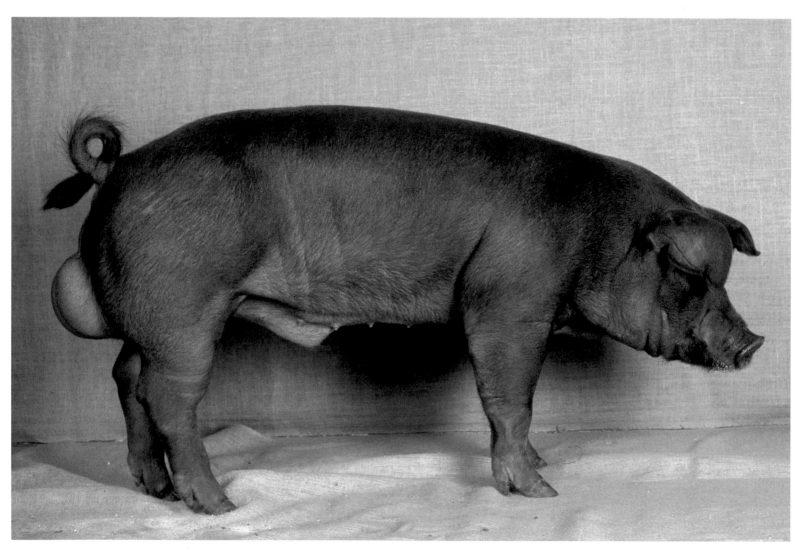

TOP: **RED WATTLE HOG** SOW, Mrs. Wattle ABOVE: **DUROC** BOAR

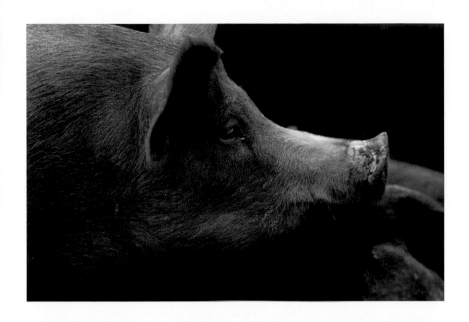

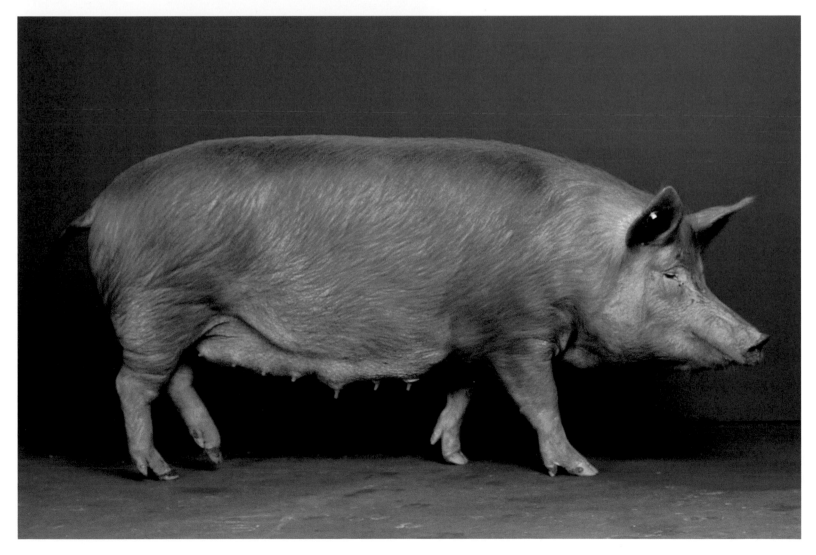

TOP: TAMWORTH SOW ABOVE: TAMWORTH SOW, *Sluteville Lucky Lass 761*

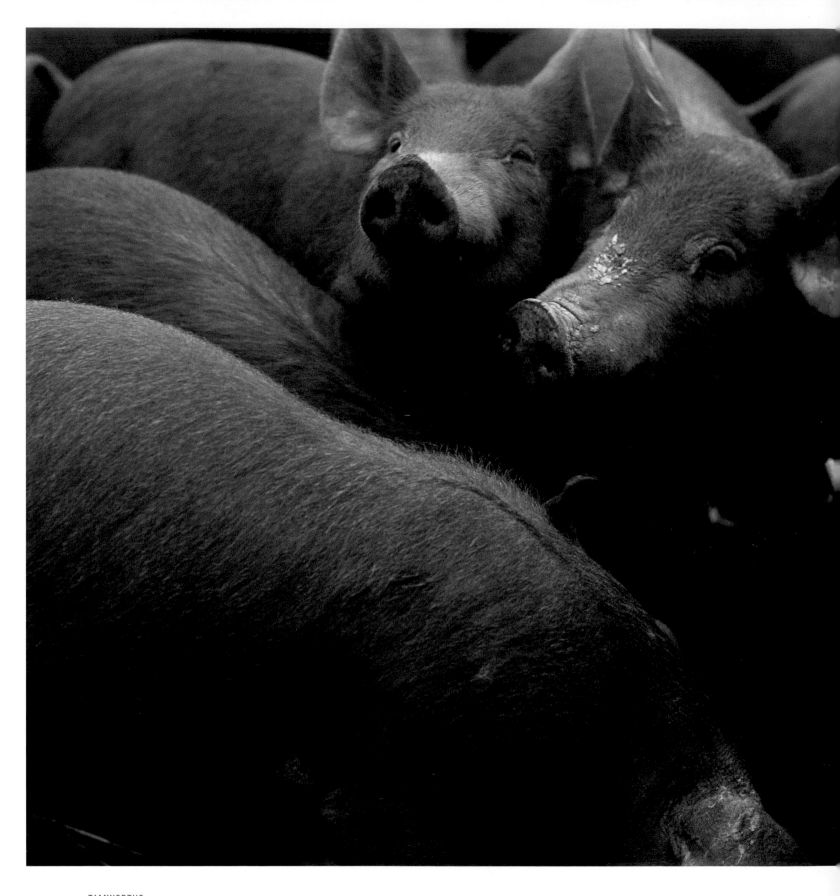

THREE-MONTH-OLD TAMWORTHS

THE TAMWORTH TWO

Many people in Britain will think of the Tamworth Two when they hear the name of the Tamworth breed. In Malmesbury, an attractive market town in Wiltshire, a truck was unloading pigs at the abattoir in January of 1998. Two enterprising five-month-old Tamworth siblings, a brother and a sister, squeezed through a fence and escaped. Search parties did not realize at first that these two athletes had gone for a swim and crossed a river.

The Western Daily Press *assigned the story to Wendy Best, whose piece began like this:*

Three little piggies went to market,
but two went on the run.
They saved their bacon with a swim in the Avon
and now the farmer's looking glum.

Alert to the prospect of a small but colorful story, London's Daily Mail *sent a reporter, and within a couple of days had ten of them in the area. A television helicopter circled and soon there were two of them clattering over this peaceful town. The hotels and the pubs were full of journalists, the streets were full of satellite trucks. The pigs were given the names Butch and Sundance and referred to as the Tamworth Two. The huge media attention became a story in itself.*

The pair had left the gardens near the riverbank and found their way into a wooded thicket, whose owner declared, "They are welcome to stay. . . . and I'd be happy for them to root out some of this undergrowth." Police spokesman P. C. Bull made a statement: "These are obviously cunning and devious animals, and it appears to be a well-planned escape."

Some media people worried that the pigs would die of cold and starvation on their January walkabout, unaware that the Tamworth is a hardy breed, and that almost any pig will find plenty to eat if let loose in the countryside. It was a week before they were found in a garden. The female was caught immediately, and the young boar was caught the following day after being tracked by a pair of pet spaniels.

The Daily Mail *bought the pigs from the owner for a reported £15,000 and placed them in an animal sanctuary where they lived happily ever after.*

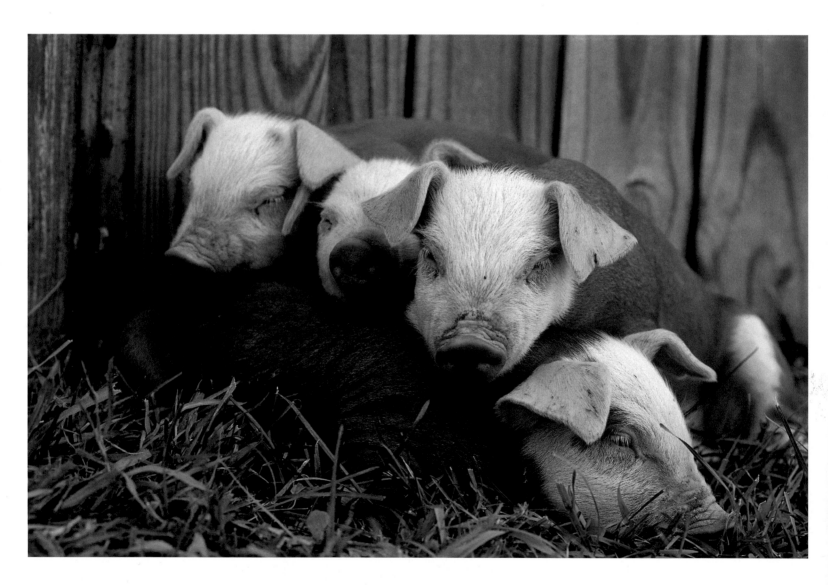

ABOVE: SEVENTEEN-DAY-OLD HEREFORD PIGLETS OPPOSITE: SEVENTEEN-DAY-OLD HEREFORD PIGLETS

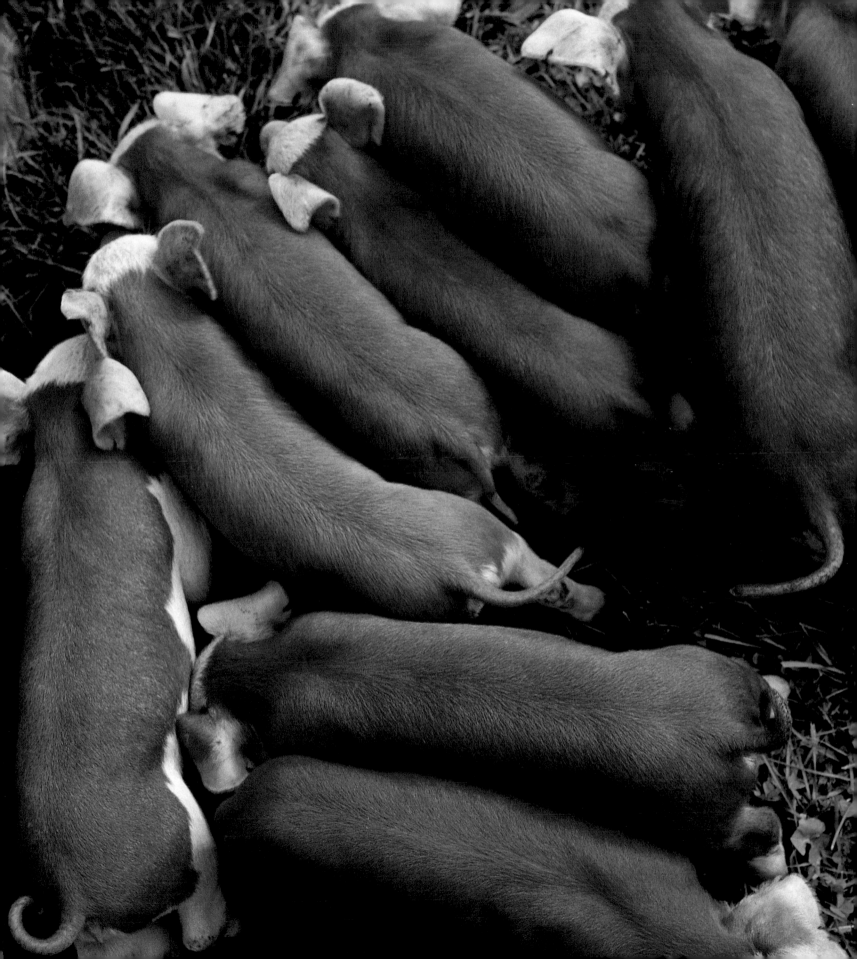

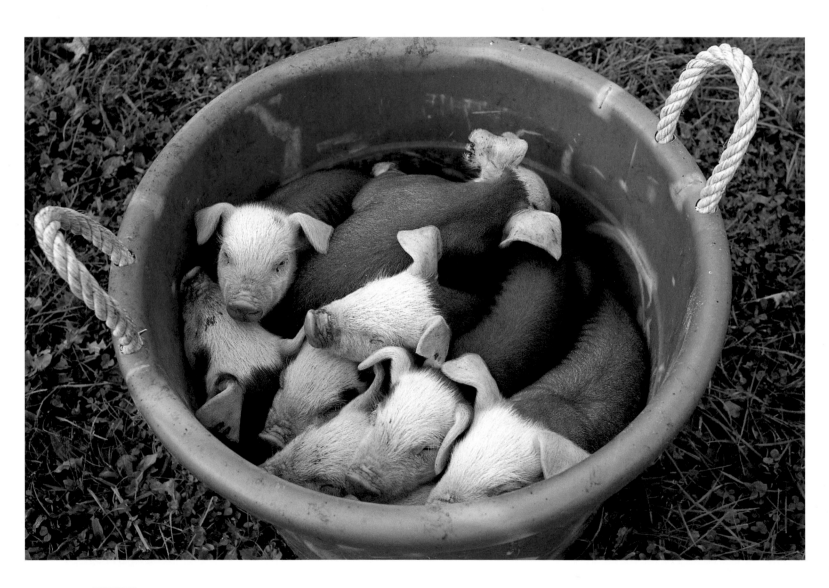

SEVENTEEN-DAY-OLD HEREFORD PIGLETS

TOP: HEREFORD BOAR, Boomer, WITH A HEREFORD HEIFER ABOVE: HEREFORD SOW, Pretty Girl

SPOTTED BREEDS

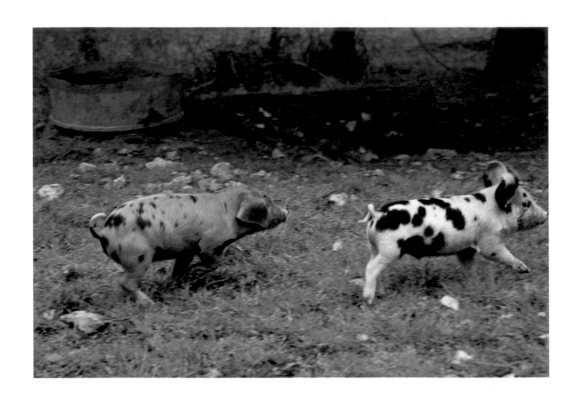

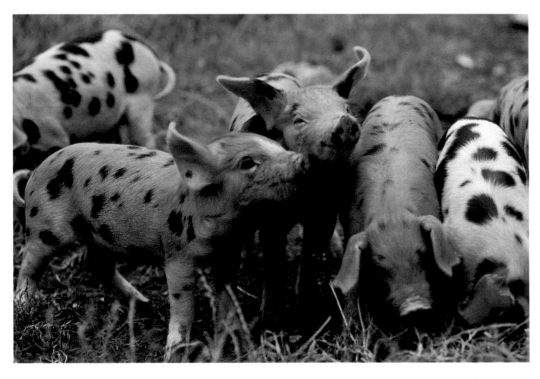

TOP AND ABOVE: FOUR-WEEK-OLD OXFORD SANDY AND BLACK PIGLETS

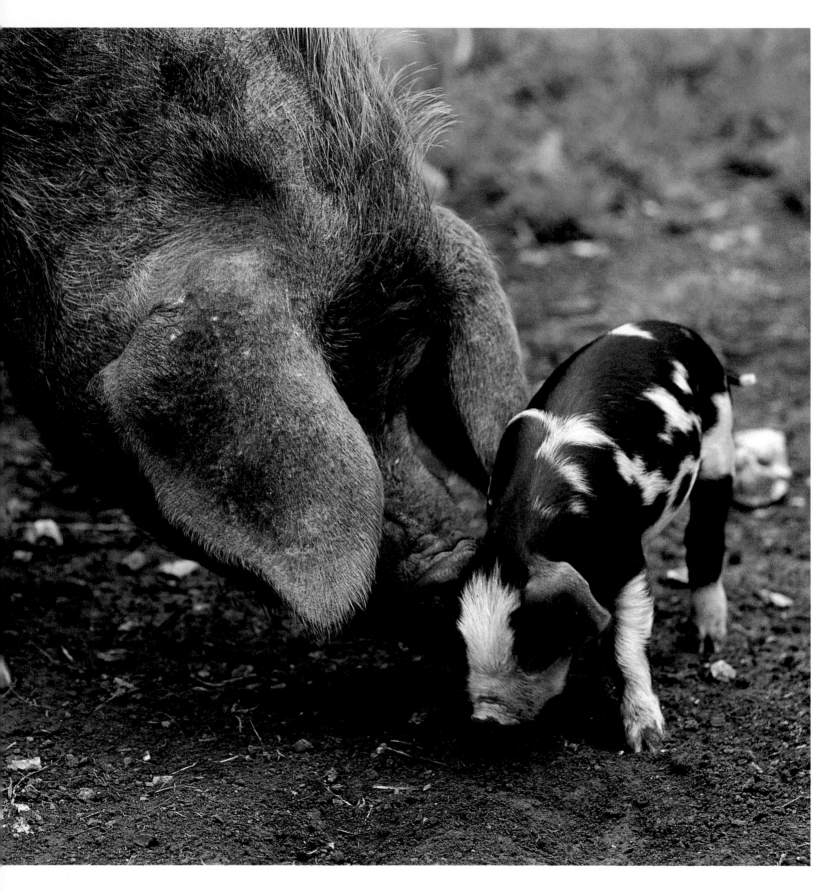

OXFORD SANDY AND BLACK, *Antsy Duchess III*, WITH A FOUR-WEEK-OLD PIGLET

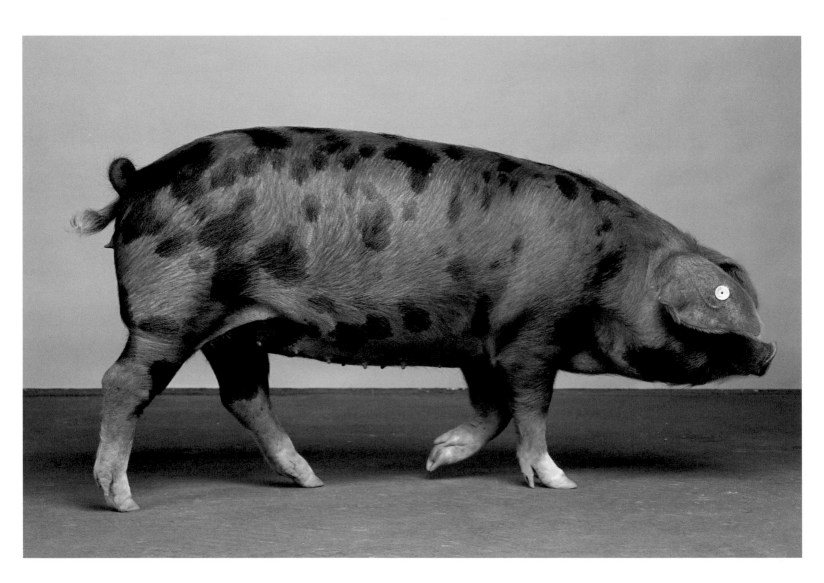

OXFORD SANDY AND BLACK GILT, *Quantock Hills Cynthia 23* or Cici

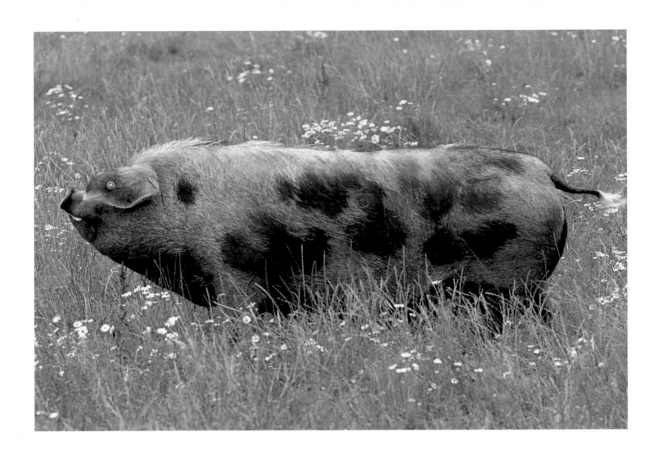

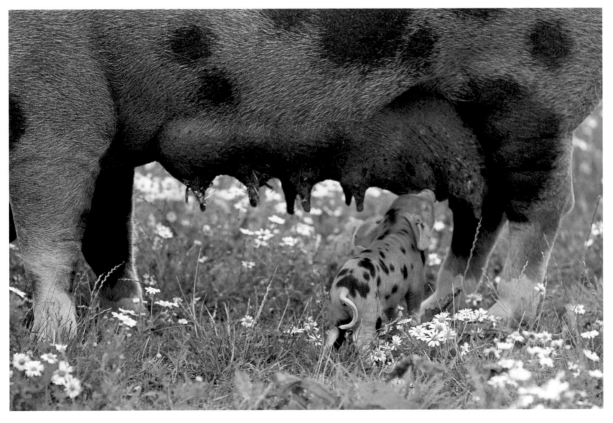

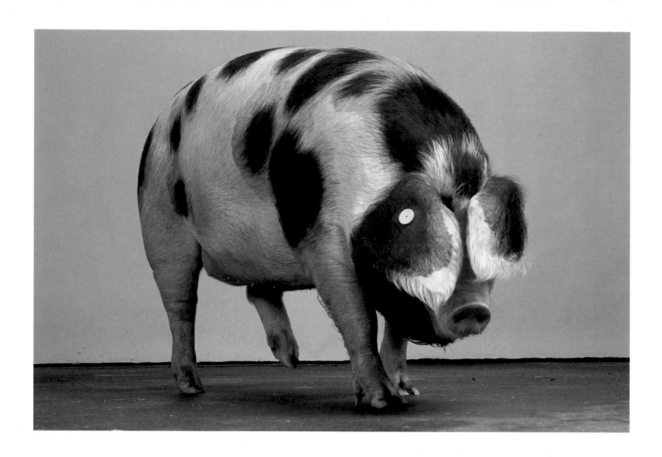

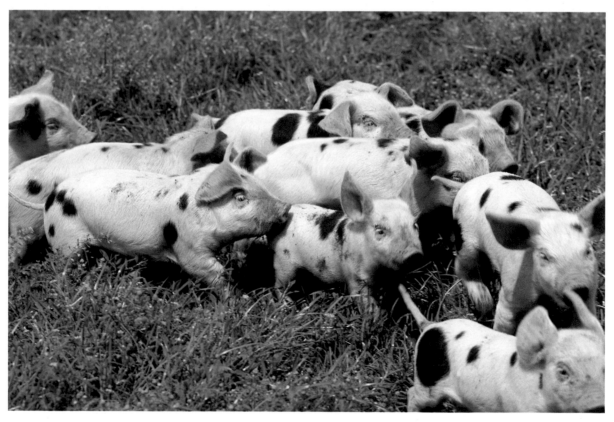

TOP: GLOUCESTER OLD SPOT GILT, *Chapel Dolly 18* ABOVE: GLOUCESTER OLD SPOT PIGLETS

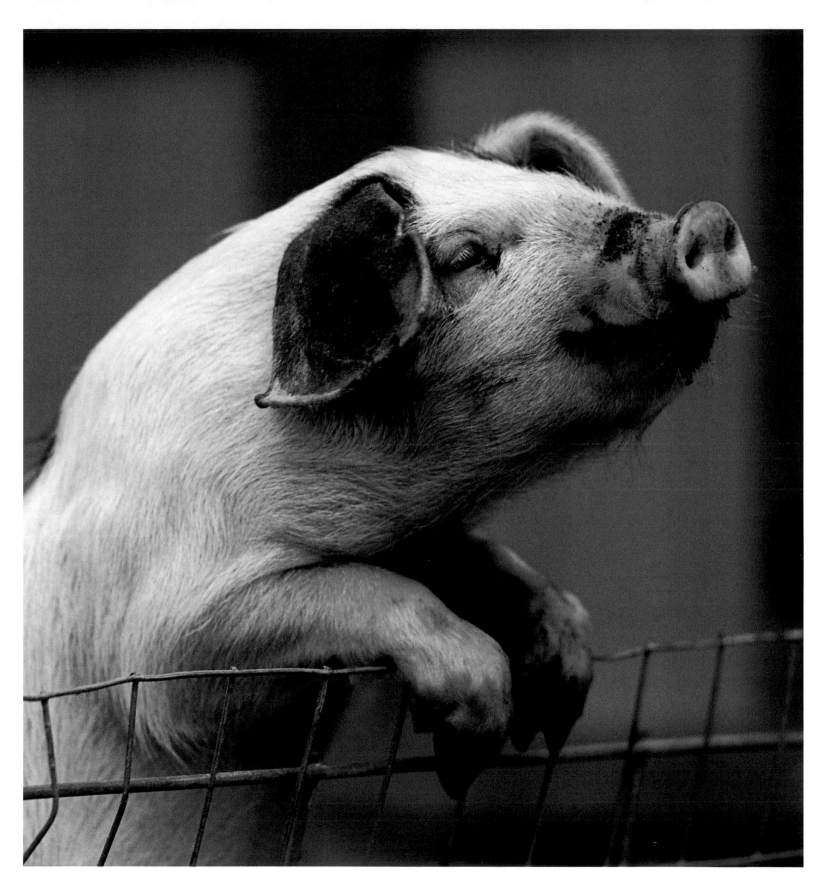

GLOUCESTER OLD SPOT GILT, *T-Meadow Farm Peaches* or Peaches

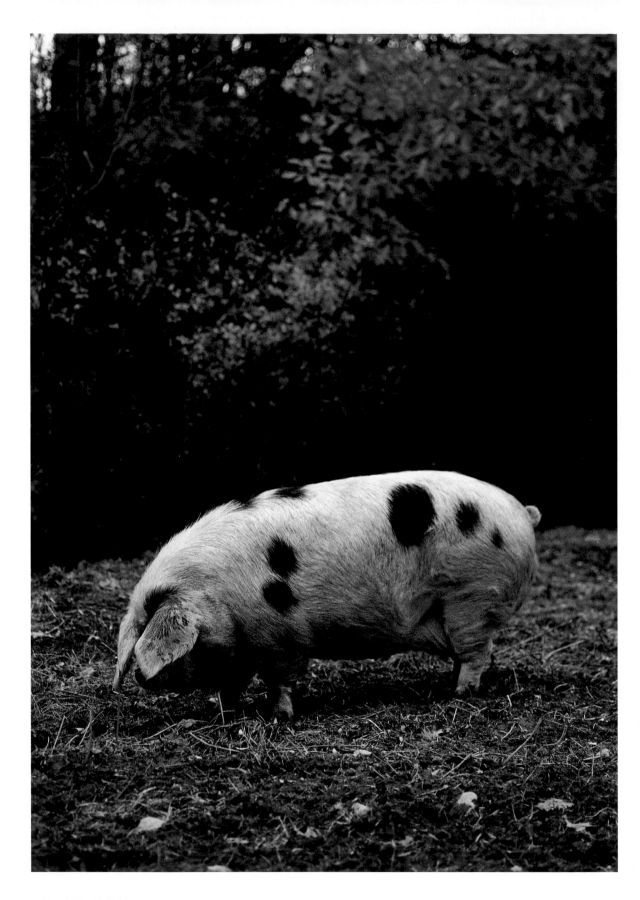

GLOUCESTER OLD SPOT SOW, Alibi

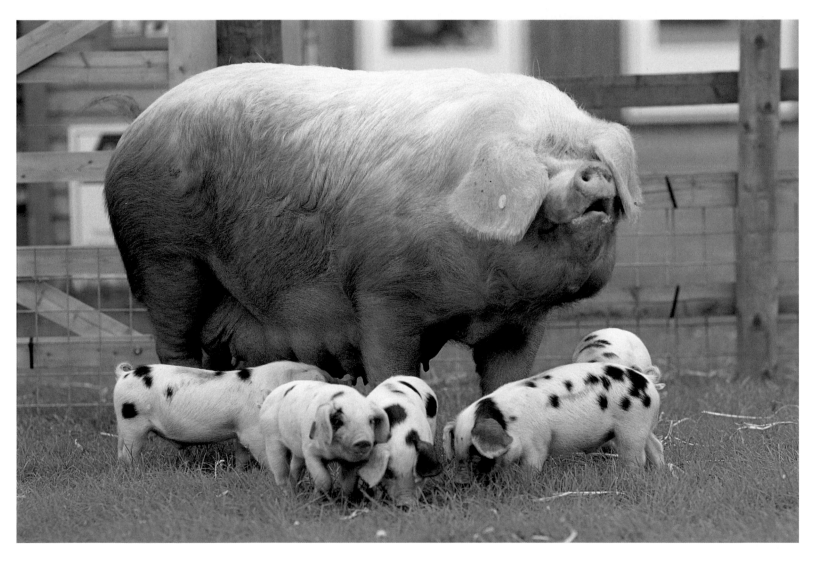

GLOUCESTER OLD SPOT PIGLETS AND SOW, *Windmill Princess Ann 3*

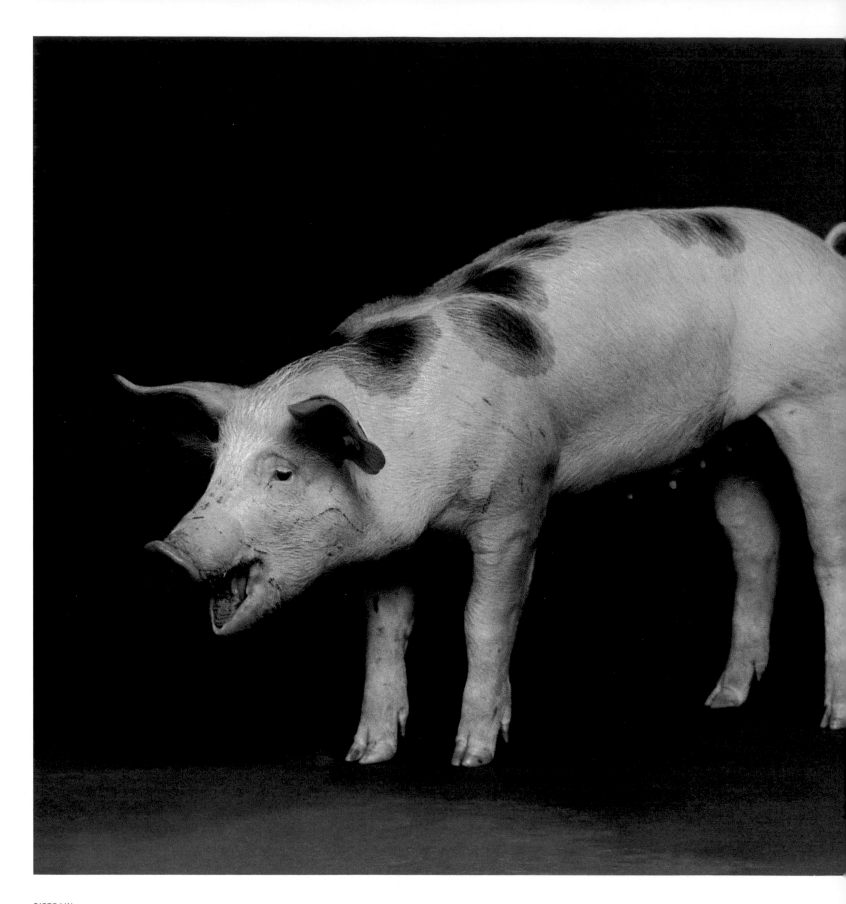

PIETRAIN GILT, *Cromwell de St. Pierre 82*

TIRPITZ

Toward the end of World War I, the German ship SMS Dresden *was helplessly cornered by two British cruisers. Rather than let his vessel fall into enemy hands, the captain ordered explosives to be set so that they could scuttle her while he and his crew escaped in lifeboats.*

The ship's pig, the lone surviving farm animal from among those kept on board for fresh milk, meat, and eggs, was not in a lifeboat. An hour after the Dresden *went down, British sailors on the* HMS Glasgow *noticed the animal swimming around nearby. It was rescued by the crew and regarded with great respect for having stayed with the sinking ship to the end, leaving it after the captain. Feeling it deserved a higher rank than captain, they named it Tirpitz, after the famous German admiral of that name. At that point, Tirpitz the Pig joined the Royal Navy, and was instantly demoted to the rank of ship's mascot.*

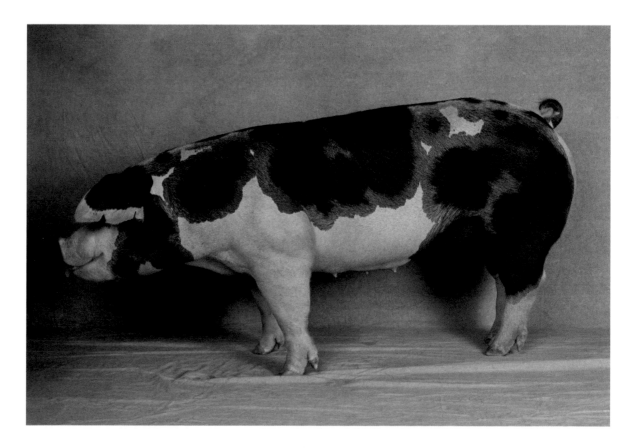

WHITE BREEDS WITH LOP EARS

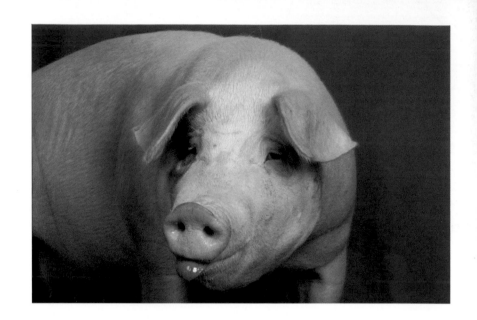

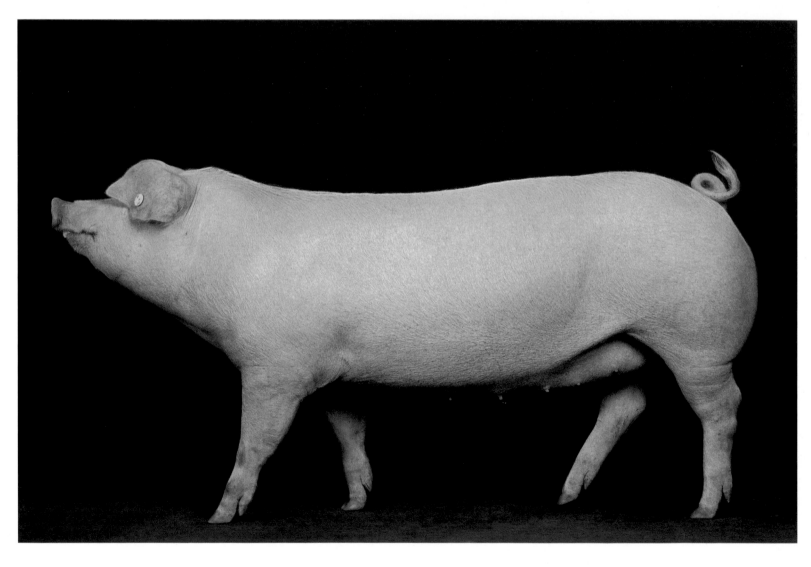

TOP: AMERICAN LANDRACE SOW, Monopoly ABOVE: WELSH GILT, *Vinery Willing 4431*

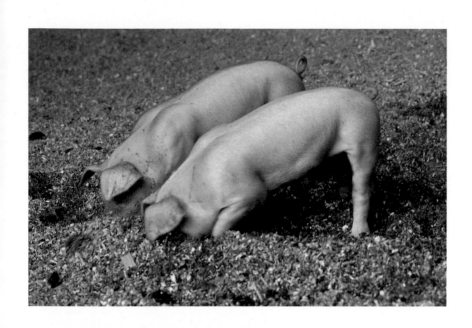

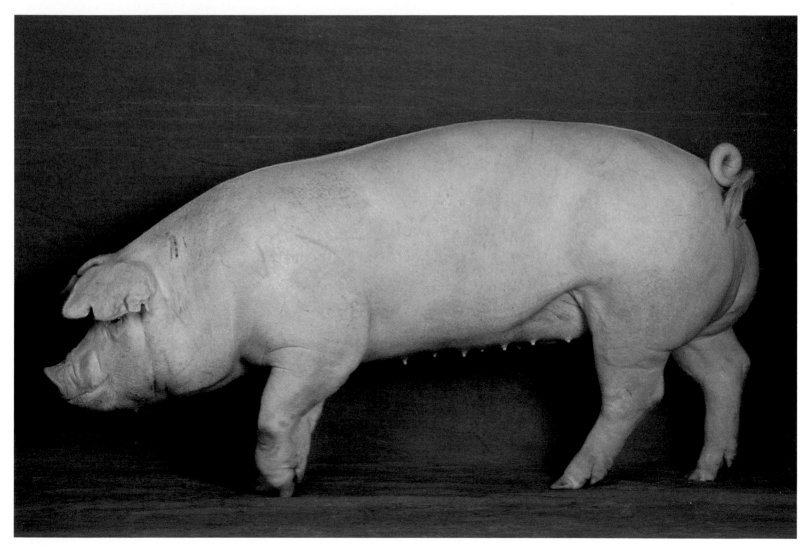

TOP: BRITISH LANDRACE PIGLETS ROOTING ABOVE: CHESTER WHITE GILT, Gloria

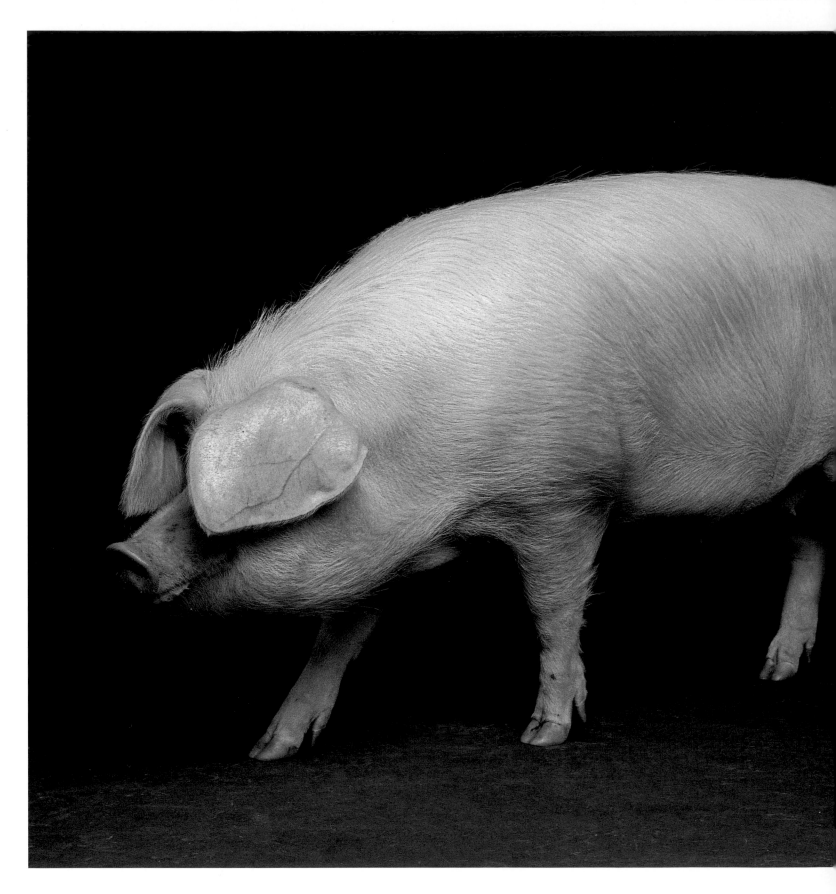

BRITISH LOP GILT, *Cilgerdem Harmony 91*

THE PIGS AND THE ELEGANT SPA

One of the most beautiful cities in England is Bath. Elegant Georgian architecture fills the city center and climbs the gentle hillsides in beautiful sweeping crescents, all made with the local, honey-colored stone. In the nineteenth century, all English society gathered for the "season," attending balls, theaters, casinos, and private parties, both large and small. Many scenes in the novels of Jane Austen are set here, and Bath is featured in works by Charles Dickens, Henry Fielding, and many others.

So it is hard to believe that this city was founded by pigs—pigs with leprosy.

Legend has it that around 860 BCE, Prince Bladud, son of the King of the Britons and heir to the throne, came down with a case of leprosy. Realizing that his kingly future was impossible, he left the royal household for the solitary life of a swineherd. Although he avoided people, unfortunately he was with a species that is susceptible to some human diseases, and he was dismayed to find that his pigs had caught leprosy from him.

One day, while he was tending his herd near what is now the River Avon, his pigs found a hot mineral spring that formed an ideal mud wallow. After his pigs had spent some time in it, Prince Bladud realized that they had been cured of leprosy. So he took off his clothes and joined them in the warm mud until he too was cured. He then returned to his family, and in due course inherited the throne.

He founded a town around the healing waters, and dedicated it to Sul, the Celtic goddess. Eight hundred years later, when the Romans were occupying Britain, they decided this spring would make an ideal place for soldiers of all ranks to take a break from military duties, so they built a complex of swimming pools and steam rooms, a remarkable spa complex that survives to this day. They called it Aquae Sulis, the Waters of Sul. Now Bath is a fine modern city, and tourists from around the world come to marvel at the Roman spa and at the hot spring that Prince Bladud's pigs had discovered.

Mangalitza

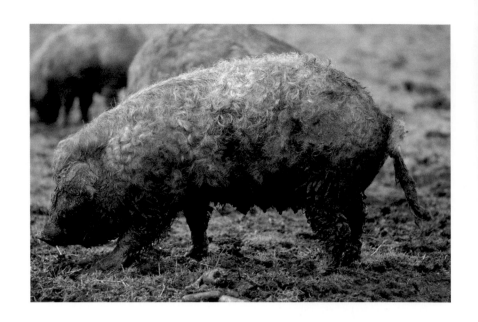

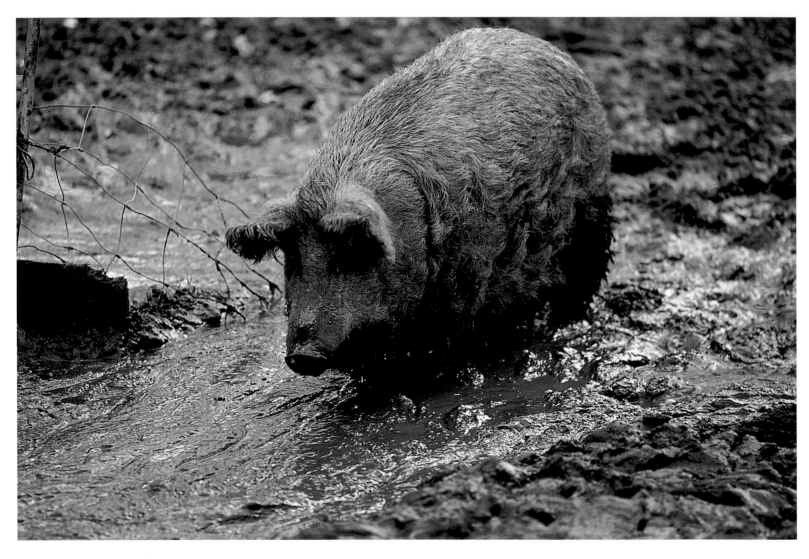

TOP: **BLOND MANGALITZA** SOW, *Paradise Princess* ABOVE: **RED MANGALITZA** SOW, *Paradise Bonnie*

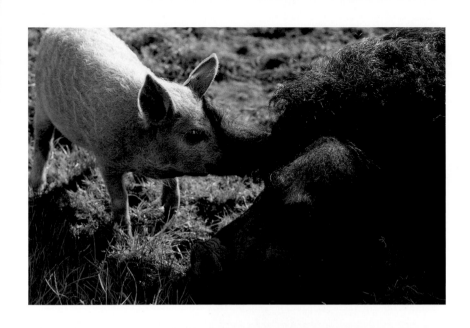

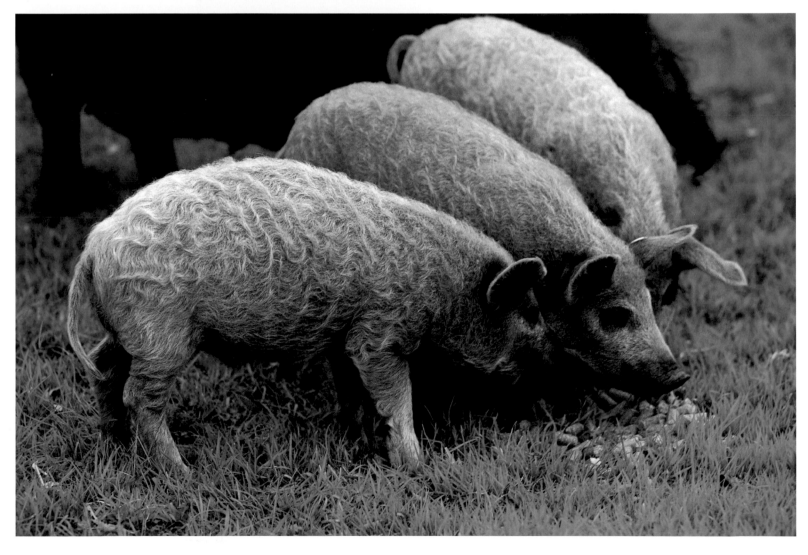

TOP: BLOND MANGALITZA PIGLET AND SWALLOW-BELLIED MANGALITZA SOW ABOVE: YOUNG MANGALITZAS: TWO BLOND AND ONE RED

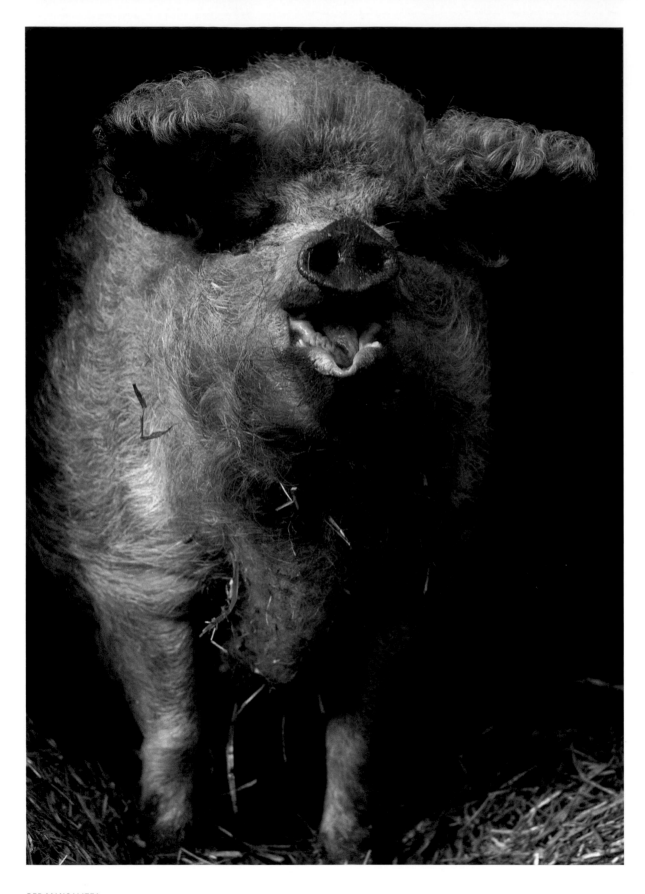

RED MANGALITZA SOW, *Paradise Abbottess* or Scarlet

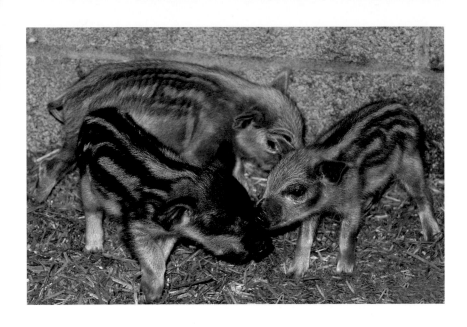

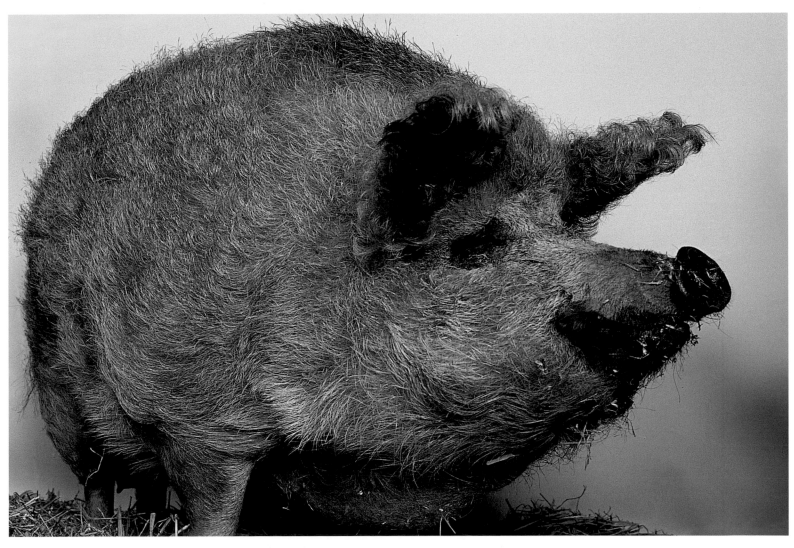

TOP: TEN-DAY-OLD MANGALITZA PIGLETS ABOVE: RED MANGALITZA SOW, *Paradise Abbottess* or Scarlet

WILD SPECIES

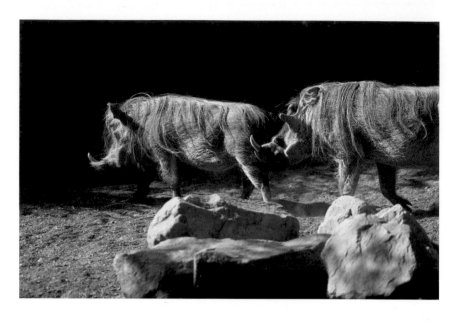

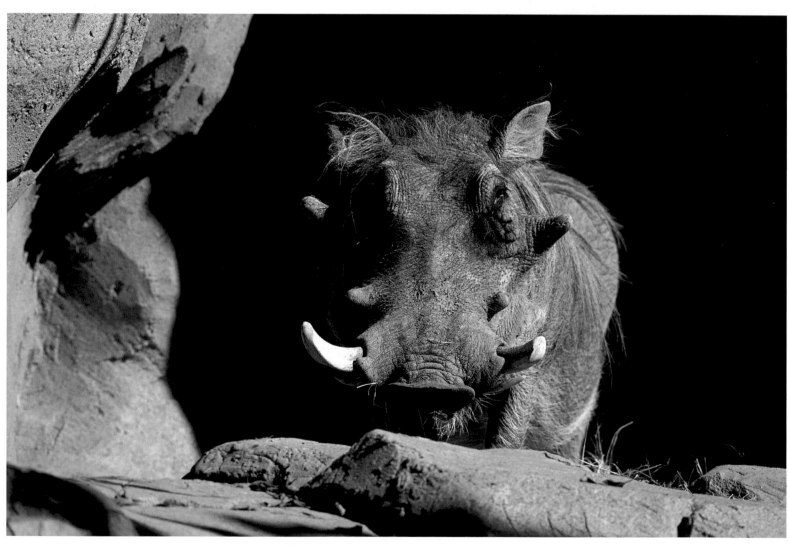

TOP: FEMALE **SOUTHERN WARTHOG,** Tufoni, BEING FOLLOWED BY A MALE, Bokkie ABOVE: **SOUTHERN WARTHOG** BOAR, Kubwa

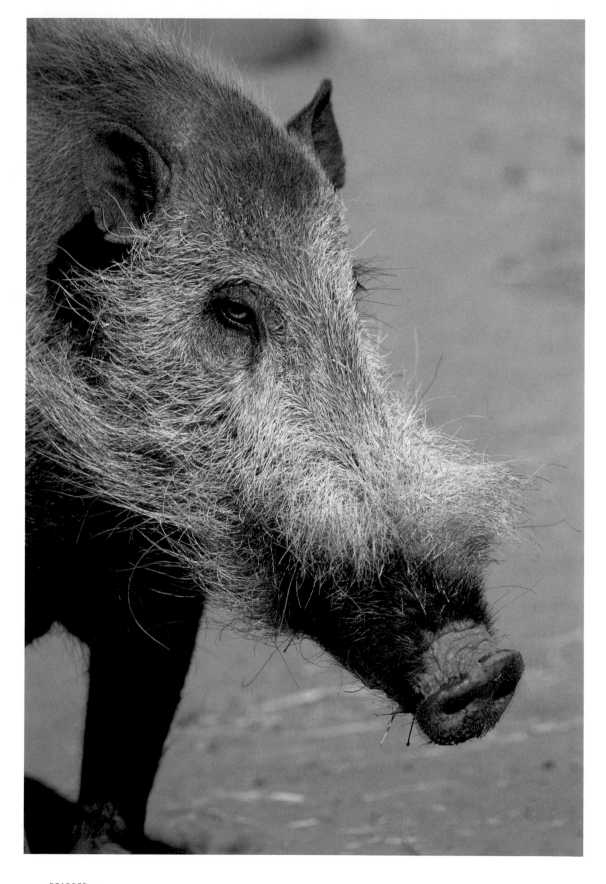

FEMALE BEARDED

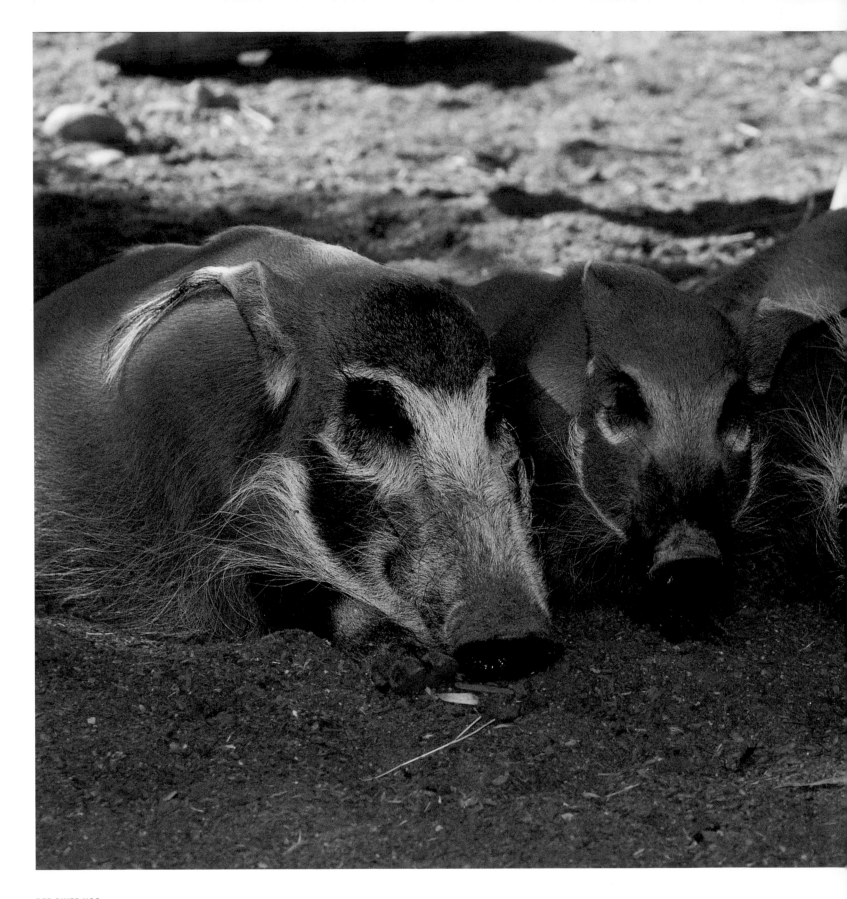

RED RIVER HOG FAMILY: mother Asali (left) and father Tarzan (right)

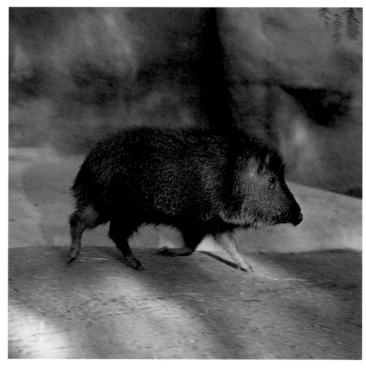

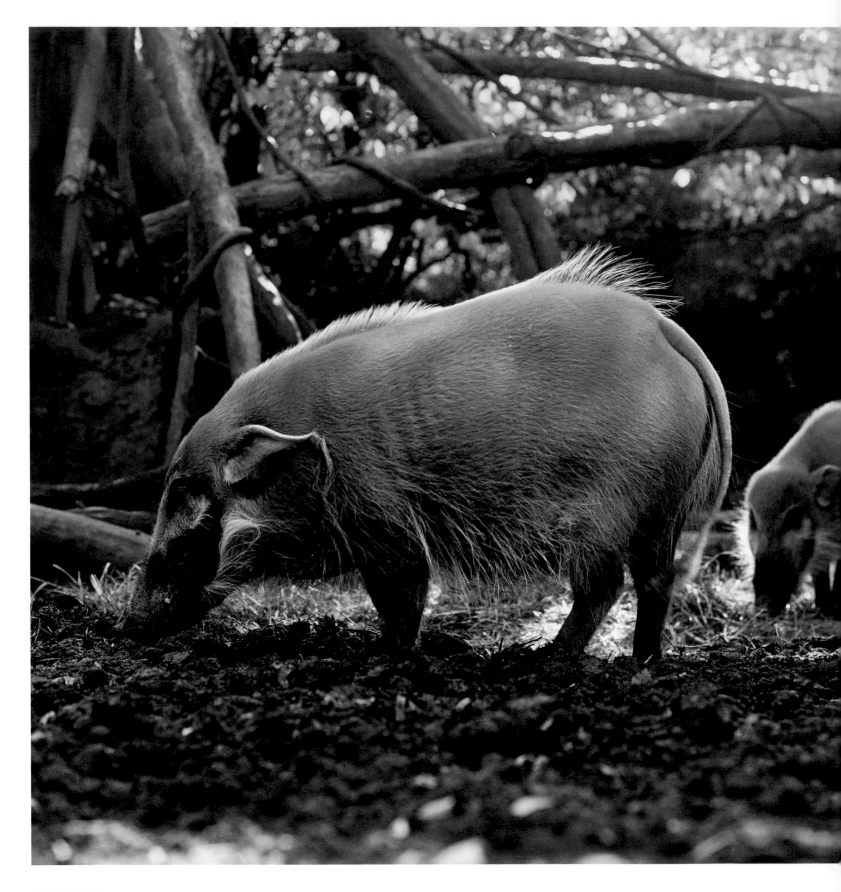

RED RIVER HOGS

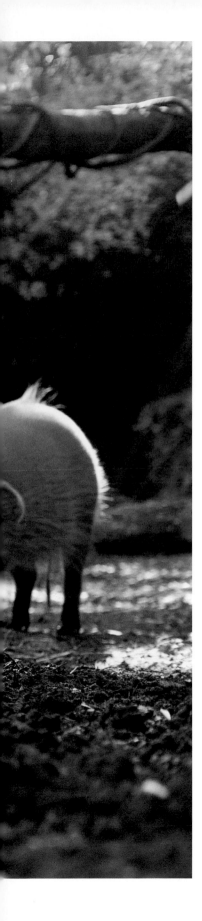

CHELSEA, A UNIQUE PIG

In a small African town in Guinea, a family lived with a black pet pig they had found as an orphaned piglet. When soldiers invaded the town, many of the inhabitants fled into the nearby forests, and the family took their pig with them. She was quite at home there since this was her natural environment, and she was soon foraging for herself. Yet, she never strayed too far from the family.

When the threat had passed, and the pig was now larger, the family decided that it would be best to place her in a zoo, and she was donated to a zoo in nearby Conakry. Later, representatives of the wonderful San Diego Zoo were looking to add interesting specimens to their collection, and they acquired the black pig and took her back to California.

Naturally she trusted people, and very soon became a favorite of the zoo staff. But pigs like to have pig friends too, so they introduced her to a Red River Hog, the runt of his litter, who was not receiving much attention from his own family. The two quickly became inseparable. He was called Oboy and she was called Chelsea. Zoo experts soon realized that she was not a small specimen of a Giant Forest Hog as they had originally believed, but actually a new and unknown species. They called her a Western Forest Hog, the first of her kind to be identified.

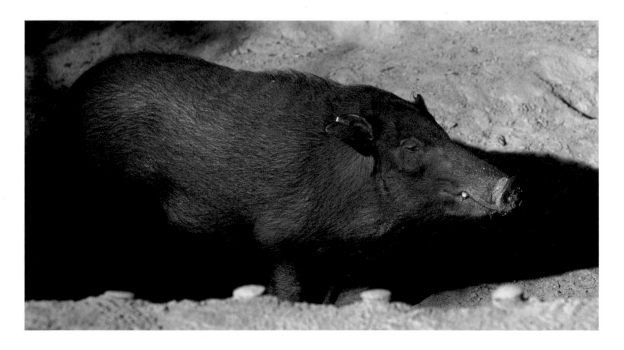

FEMALE **WESTERN FOREST HOG,** Chelsea

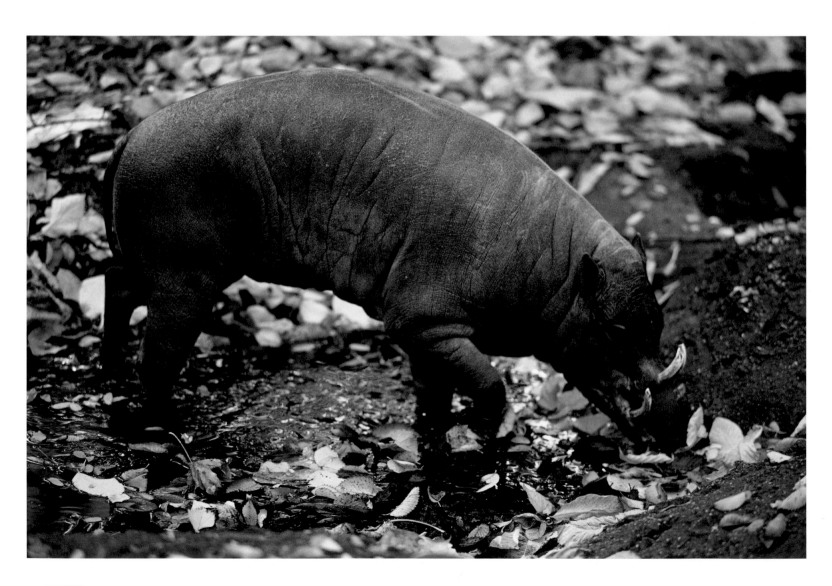

MALE BABIRUSA, Sidu

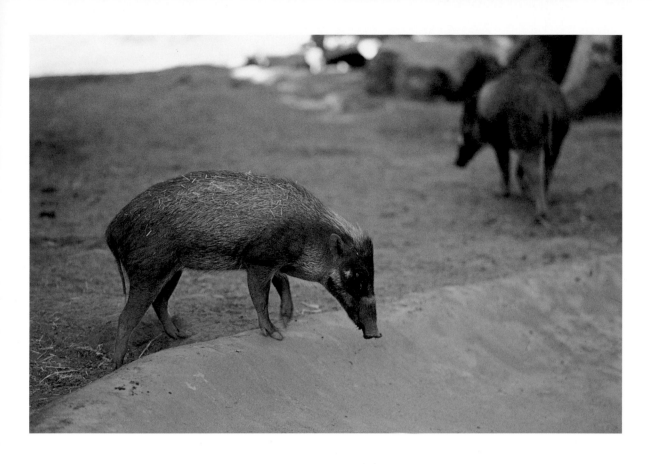

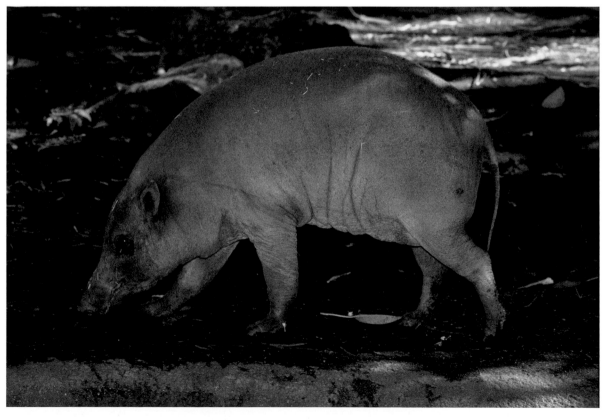

TOP: VISAYAN WARTY ABOVE: FEMALE BABIRUSA, Natasha

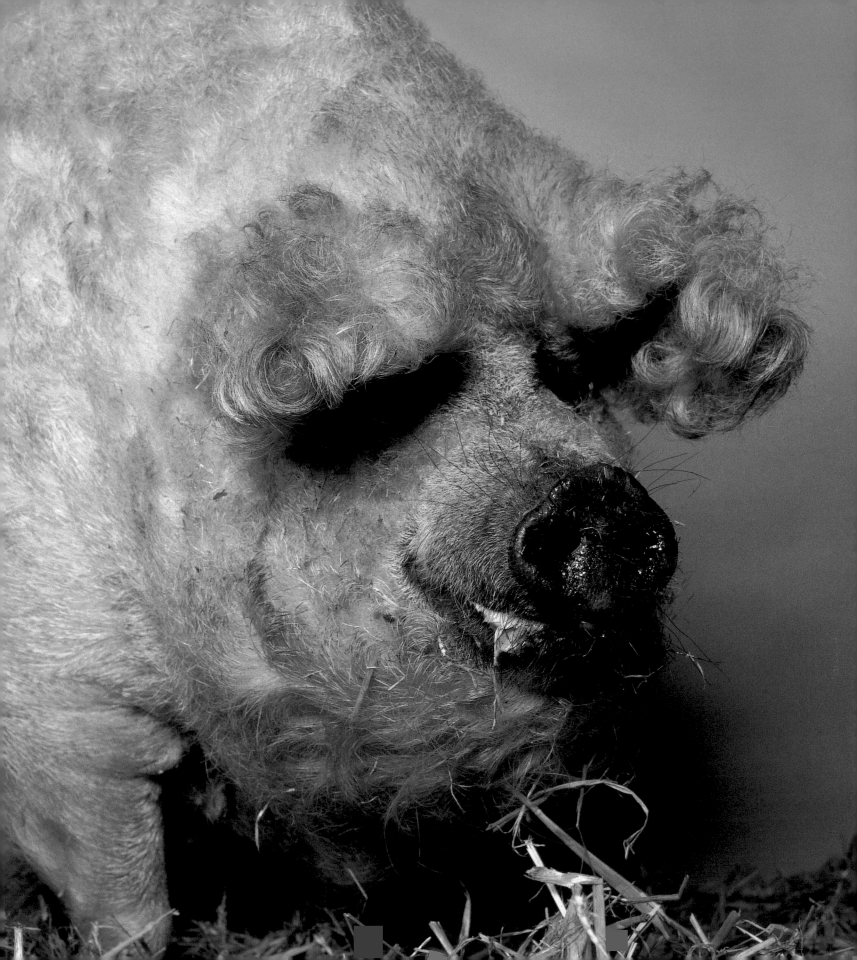

ABOUT EXTRAORDINARY PIGS

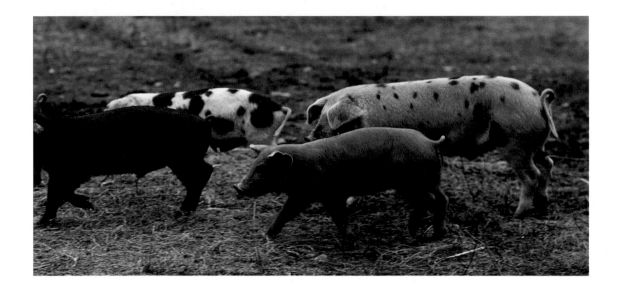

A t one extreme of breeding and raising pigs are the huge commercial operations that supply pork, ham, and bacon to supermarkets and to most restaurants. At the other extreme is the family with a miniature pig as a pet, the pig perhaps treated the same as a family dog and most certainly not destined for the dinner table. In the middle are independent farmers raising select heritage breeds for serious cooks and for chefs at high-end restaurants. And at a quite different extreme are wild, undomesticated species.

It is believed that about 19 million years ago the ancestors of what are now the wild species of Africa and Southeast Asia split from the species that evolved into our domestic pigs. These prehistoric creatures appear in cave paintings, and those at Altamira are 30,000 years old. Humans first domesticated the Wild Boar a little more than 9,000 years ago in eastern Turkey, and somewhat later in China. This was at the dawn of agriculture, when some men turned from hunting to husbandry. Domestication in Central Europe and Italy occurred even more recently, around 3,500 years ago, followed by the rest of Europe and the British Isles.

During these early centuries, pigs figured in mythology and religion. In ancient Egypt and Greece, Celtic Europe, and India, pigs were both revered and reviled. For the most part attitudes were positive, with boars being respected as fierce, courageous warriors, and sows usually represented as goddesses of fertility, motherhood, and abundance.

OPPOSITE: BLOND MANGALITZA SOW, *Paradise Pride* or Blondie

ABOVE (left to right): OSSABAW ISLAND/LARGE BLACK CROSS,

GLOUCESTER OLD SPOT, TAMWORTH, TAMWORTH/GLOUCESTER OLD SPOT CROSS

It is known that ancient Romans cured pig meat to make bacon, and even made sausages. These skills were lost during the Dark Ages. In medieval times, the Celtic pigs of northern Europe had longer legs and more hair than today's specimens, and the landscape was covered with far more thick woods and forests, good habitats for pigs who like to forage among trees. Their more athletic physiques were well suited to the distances they covered seeking food.

In Anglo-Saxon times, ownership of several pigs was a sign of wealth. As sea travel and world commerce developed, Europeans discovered different pigs in China, Siam, and other Eastern countries. In the seventeenth and eighteenth centuries many of these unfamiliar breeds were imported and crossed with European pigs, and many of their traits can still be seen in today's breeds. The imports brought shorter legs, flatter faces, prick ears, darker skin, more fat, lighter bones, and meat that was more tender. Other advantages include larger litters and faster growth.

Increased sea travel also brought pigs to the New World. In the Americas, the closest indigenous species to a pig was the Peccary, but in 1539, Hernando de Soto brought domestic Spanish pigs to North America. In the space of a few years his small herd became 700 animals; some of them became feral, while some evolved into the formidable Razorbacks of the American South. Through the years explorers and settlers continued to bring livestock to the Americas, as well as to other colonies. In the centuries before railways and refrigeration, most farms and livestock were kept on a small scale, often just in the backyard.

By now, pigs have fed more people in the world than any other creature. While more chickens have been consumed, a chicken provides far fewer meals than a pig. It is estimated that there might be 800 million pigs in the world at any given time, with about 335 million in China alone. Although all animal protein from domestic creatures represents a very inefficient use of vegetable protein, pigs are three times more efficient than sheep and cattle, consuming a third of the amount of fodder for each pound of meat.

Unfortunately, almost all of the pork, ham, and bacon consumed in the developed world comes from enormous factory farms, or "intensive farming." In fact, the word "farm" is inappropriate; Concentrated Animal Feeding Operation (CAFO) is more accurate.

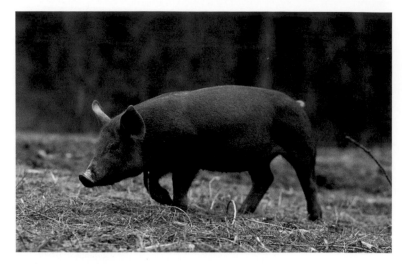

THREE-MONTH-OLD TAMWORTH

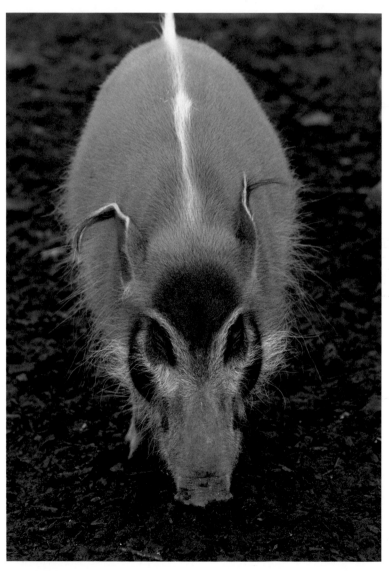

RED RIVER HOG

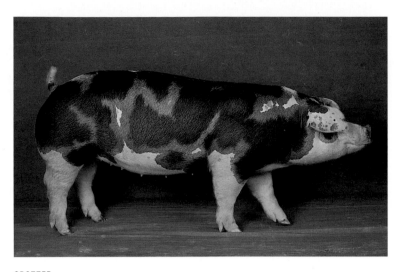

SPOTTED GILT

As with many goods and services in the decades since Henry Ford's production line, it has been established that large-scale operations can reduce the cost per unit, making an enterprise more profitable.

Serving these operations are companies that provide breed combinations that ultimately lead to the greatest profits. From a profit-making standpoint, desirable characteristics include large litter sizes, sows that are effective mothers with a good milk supply and high piglet survival rate, speed to sexual maturity, speed to harvesting weight, high ratio of carcass weight to food consumption, high percentage of lean meat, docile temperaments, tolerance of crowded indoor facilities, and resistance to disease. It seems that the flavor of the meat is not a priority. Breed research companies employ biologists, geneticists, veterinarians, and whatever other scientists might help them achieve their goals.

The giant indoor facilities where these pigs are raised under extremely cramped and sometimes unhygienic conditions are similar to the operations that raise chickens for mass consumption. Unless laws are passed, conditions will not improve until consumers learn to accept the higher costs of more tasty pigs raised with less ruthlessly efficient methods. To date, the European Union and seven American states have banned a certain type of crate that is inhumane, but more needs to change. Perhaps the recent rise in demand for organic food and locally grown meat and produce is a signal of changing attitudes.

In many businesses, it is sad to see giant chain operations overwhelm small independents, benefiting from economies of size and bullying suppliers, and we mourn the loss of small neighborhood shops. In the case of small farms, we also lose two things that cannot be recovered: We lose parts of the rural landscape that we love, and we can lose certain livestock breeds.

We regret the loss of many wildlife species that have become extinct and we agonize over the imminent disappearance of others, yet the loss of specific domestic livestock and poultry breeds is also tragic. Some would argue that we are only destroying what we have ourselves created. On the other hand, the loss is an insult to those who have worked so hard, often with great dedication, experience, and intelligence over a period of decades, to create breeds for specific needs. Some breeds have been replaced by versions that at one time were perceived to be improvements. Some may have seemed to

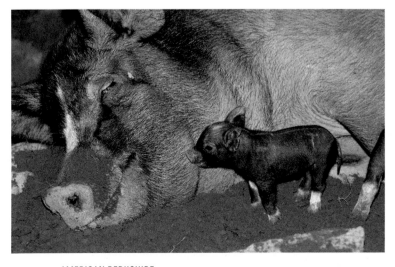

ONE-WEEK-OLD AMERICAN BERKSHIRE PIGLET WITH SOW

become obsolete as conditions and markets changed (and perhaps those changes in conditions and markets may have been only temporary). While seeking improvements, we would have done well to retain characteristics from the earlier versions of those breeds. This does not apply only to pigs; sheep, cattle, and other livestock breeds have been lost in the same manner.

This is not mere nostalgia. Some of the more obscure pig breeds could provide the building blocks for hypothetical future masterpieces of breeding. And many less common pig breeds have flavor and texture that is far superior to the tasteless, watery meat found in supermarkets today. There are butchers with a clientele of home cooks who understand the differences between breeds and have their favorites. Similarly, many restaurant chefs place orders with their suppliers for specific breeds, even requesting pork from certain local farms. We need enough discerning buyers to keep the less commercial breeds of pigs in demand; it is ironic that we need to slaughter them in order to save them. Fortunately, most of the pig breeds that are rare and endangered today are being protected and promoted by organizations that value their unique characteristics.

In 2009, a blind tasting of pork was conducted at Ayrshire Farm in Virginia, featuring the meat of various breeds in the United States. Ninety experts—chefs, food writers, and other connoisseurs—participated. Included in the three highest-rated breeds were two that are extremely rare and in danger of being lost: the Mulefoot and the Red Wattle Hog. Supermarket pork from a large producer was second to last in the taste scores. Sadly, most consumers are unaware that shopping at a good specialty butcher could expose them to taste experiences that would justify the extra cost in dollars and in shopping time.

In Britain, labels indicating "Pedigree Pork" are guarantees that the pigs do have substantial pedigrees on record, and that they have lived on real farms, mostly small farms, in healthy conditions, and have been allowed to mature at a natural rate and have not been given hormones or antibiotics. Many farms around the world raise their pigs in good living conditions with areas to forage or graze, shelters for bad weather, and secure areas in which the pigs can give birth and raise their piglets. And some farmers abide by the conditions that allow them to call their meat "organic."

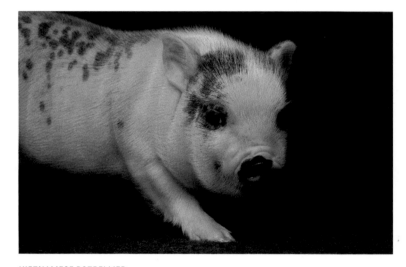

VIETNAMESE POTBELLIED PIGLET

RED MANGALITZA SOW, *Paradise Abbottess* or Scarlet

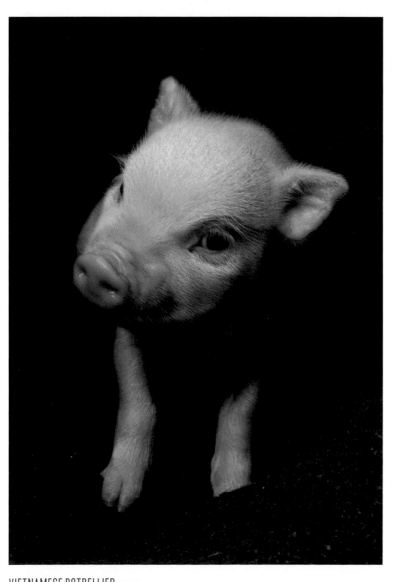

VIETNAMESE POTBELLIED PIGLET

Pigs have been bred for so many centuries that there is now enormous physical variety. Tiny pigs bred as pets or for medical research can weigh as little as five to ten ounces at birth and reach only fifty to sixty pounds as adults, though eighty to one hundred fifty pounds is the norm. When surgeons use pig organs and other parts for transplants, they prefer animals close in size to human patients.

At the other extreme are breeds that grow to weigh 800 to 1,000 pounds, and these can be hard to move without the promise of food motivating them. The size record, from 1933, belongs to a Poland China boar called Big Bill, who stood five feet nine inches at the shoulder and weighed 2,552 pounds. In the past, some powerful pigs with long legs have been harnessed to the plow like oxen, or used to pull carts. The prehistoric species Dinohyus were the size of bison.

An impressive characteristic of pigs is their high intelligence. Sometimes it is hard to perceive this since most of us seldom have the opportunity to witness their active minds at work. It is well established that pigs are considered one of the most intelligent creatures on the planet, and some scientists estimate that pigs are not far behind dolphins. Farmers have learned to respect their remarkable ingenuity when it comes to their ability to open complicated latches and door fasteners of various designs; these farmers maintain that pigs carry a Houdini gene. Many people who dismiss pigs' superiority over dogs might be forgetting that we train dogs to live with us domestically, to perform tasks for us, and so they learn what is expected of them. Pigs are seldom trained, but they can be taught to do most things a dog can do, and owners of miniature pigs say that they can be house-trained more quickly than puppies.

Livestock shows offer a good opportunity to see a variety of breeds, from the commercially successful to the rare and endangered. These events give farmers an opportunity to share information and experiences—to see what is possible. Trades are negotiated and arrangements for stud services are made. Success with show judges can increase the value of breeding stock, as at dog and cat shows. As at those events, the pig specimens are groomed to look their best. It can be enormously satisfying to look at pigs with good conformation, attractive colors, interesting patterns, striking belts, faces full of character, and in some cases, curly coats. It can also be satisfying to look at photographs of them in the pages of this book.

BREED AND SPECIES NOTES

Most of my research was collected from books listed on page 112. I have also used the literature published by organizations representing and promoting the various breeds. Plenty of information about specific breeds is available online if readers would like to seek out additional facts. While a wealth of historical information exists, crossbreeding activities have not been consistently well documented by the farmers, so some notes in this area may seem vague. For the most part I have avoided describing the appearance of the various breeds, since this can be seen clearly enough in the photographs.

— BREEDS —

AMERICAN BERKSHIRE

In 1823, some Berkshires were brought to the United States from England, and fifty years later, an American breed society was formed. In addition to fine flavor, Berkshires have the added advantages of early maturity and an efficient conversion rate of fodder to meat. Today, most of the pork sold in supermarkets and served in the majority of restaurants originates in the huge factory farms, which breed and raise white pigs and hybrids. Since the Berkshire is not considered a commercial breed, its survival depends on its appeal to discriminating butchers and restaurants, which are aware of the taste advantages of less common breeds. Some farms raise these pigs to standards that qualify as organic.

This hardy breed can be kept outdoors in most weather year-round. At Stone Barns farm, located on what used to be the Rockefeller estate near the Hudson River, the pigs and piglets live outdoors on wooded acres and supply organic meat to two restaurants owned by Chef Dan Barber: Blue Hill at Stone Barns on the farm itself and Blue Hill Café in New York City, two of the most respected restaurants in the country.

In recent decades, boars and semen have been sent back to Britain from the United States, as well as from Australia and New Zealand, broadening the genetic base, and at the same time ensuring the historic consistency of the breed.

BERKSHIRE

In Britain, the breed is pronounced "Barksher," like the English county for which it is named, often abbreviated as Berks, but pronounced Barks. This is an old breed, but the farmers of 200 years ago would not recognize the animal that bears this name today. The breed known in 1790 was large and usually red or tawny with black areas or spots, which is closer in coloring to today's Oxford Sandy and Black breed. In fact, at one point it had been called the Berkshire and Oxford. What appears to be the earliest reference to the Berkshire comes from an account of Oliver Cromwell's troops enjoying the local bacon and ham when in the town of Reading, Berkshire, during the first half of the seventeenth century.

Early in the 1800s, the breed began to change with the introduction of blood from Chinese and Siamese pigs. During the 1820s, Lord Barrington became the most active breeder, introducing Neapolitan pigs, which had previously been influenced by Asian breeds. By the end of that decade the Berkshire looked more like the pig we see today, and had become very popular, particularly with the aristocracy, gaining the nickname the Lady's Pig. Queen Victoria even had a herd at Windsor Castle. It wasn't until 1884 that a breed society was formed, and this was later absorbed by the new British Pig Association in 1927. Today there is a very active Berkshire Pig Breeders Club.

The breed's main asset has been the quality of the meat. In the Far East it is considered a delicacy. The pork is popular in many restaurants

and a common choice among farmers converting to organic standards. Though the Berkshire is black, the carcass is like that of a white breed. Among other virtues, it is loved for its placid temperament and its sturdiness in the face of extremes of weather.

BRITISH LOP

Though it is a white pig, the British Lop is in many ways similar to the Large Black. There was an assumption at one time that white pigs could not tolerate too much sunlight, but the British Lop is content to live outdoors. Its origins can be found in the Celtic pigs of northern Europe. It thrived in the southwest corner of England, in the counties of Devon and Cornwall, gradually spreading to neighboring counties, and even to Scotland. Alternative names include Cornish White and Devon Lop, and even the cumbersome National Long White Lop-Eared Pig. It has many characteristics in common with the Welsh, such as size, shape, color, ear carriage, and meat quality, and for a couple of years in the 1920s, the two breed societies amalgamated.

The docile temperament and longevity of the British Lop make the breed popular on small family farms, where these pigs are able to fend for themselves and thrive on scraps and farm waste. Not used in large-scale operations, the British Lop is considered a rare breed today.

BRITISH SADDLEBACK

The markings of the black-and-white Saddlebacks are similar to those of belted cattle, except that the white area covers the shoulders and extends down the front legs, rather than being in the middle of the back as a saddle or belt might be. The width can vary from animal to animal, and on either side of the white there are well-defined strips that are a mixture of white and black hairs.

Historically, different parts of England had Saddlebacks that looked similar. In the three counties that make up East Anglia, there was an Essex Pig, while the Wessex Pig was to be found in south central and southwest England. Ironically, a prominent breeder of the eastern pigs was called Lord Western. He introduced Neapolitan blood after admiring the breed in Italy, but neither the Wessex nor the Essex was affected during the period when it was common to introduce Chinese blood to modify English pigs. The breed societies of the Essex and Wessex amalgamated in 1918, but it was not until 1967 that the British Saddleback became the name for both types. Both the Essex and the Wessex were extremely popular during World War II, and in the late 1940s almost half of England's registered sows were one or the other. Gradually the white breeds that are better suited to intensive commercial farming became more popular, but Saddlebacks are still valued for their hardiness and the fact that they graze outdoors. They are often the pig of choice for organic farms.

CHESTER WHITE

Originally from Chester County, Pennsylvania, the Chester White was derived from various English breeds, some of which are now extinct, including the Lincolnshire Curly Coat, the Cumberland, and the Bedfordshire. The breed society dates back to 1884. The Chester White later became associated more with the American Midwest than with Pennsylvania, as breeders took these pigs to Ohio, mated some with breeds from England and Ireland, and raised them on corn. For a while they became lard pigs, but today the Chester White is considered a meat pig.

Chester Whites are prolific, and can grow quickly to a good size, with sows around 450 pounds and the boars between 600 and 900 pounds. Their ears are unusual, being neither upright prick ears nor lop, but somewhere in between. This is one of only eight American breeds acknowledged by the National Association of Swine Records, and these same eight breeds are the ones to be seen at major North American livestock shows.

DUROC

Saratoga Springs, New York, has a long tradition of horse racing. So when Isaac Frink bought a fine red boar from Harry Kelsey in 1823, he named it in honor of Kelsey's famous trotting stallion, Duroc. From this boar came pigs that grew quickly into healthy adults, with broad hams and efficient conversion rates of fodder to meat. Although active, they tended to have pleasant personalities.

Meanwhile, there was a somewhat larger red pig in the state of New Jersey, known as the Jersey Pig. In the second half of the nineteenth century, the two red types were bred with each other, eventually producing a successful combination, the Duroc-Jersey. The American Duroc-Jersey Association was established in 1883.

The coat of the Duroc changes with the seasons, being thick and warm in the winter, and molting practically to baldness in the hot months. Some specimens have been exported to England, where they have been successfully crossed with native breeds, but the Duroc remains an American pig.

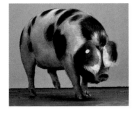

GLOUCESTER OLD SPOT

North American readers who may be unfamiliar with the name can overlook one syllable and just say "Glosta." Though pedigree status and a herd book date back only to 1913, the Gloucester Old Spot is an old breed in Britain, judging from nineteenth-century prints and paintings. For many years it was mainly a local breed, found in Gloucestershire and nearby counties, but today the pigs are widely distributed, and can even be seen on several farms in the United States.

A period of sudden popularity in the 1920s and 1930s led to overproduction of the breed, damaging its reputation for high quality. By now the breed has recovered and is once again in demand, with butchers and fine restaurants clamoring for the large pigs for roasts, chops, hams, sausages, and bacon.

Gloucester Old Spots are easy to handle and are happy to forage and graze outdoors year-round. They are opportunistic feeders, and their taste for fallen fruit in autumn has given them the nickname Orchard Pigs.

GUINEA HOGS

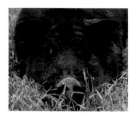

Guinea Hogs are rare and are likely to remain so—their small size and high fat percentage makes them unpopular in today's market. There was a time when their size worked in their favor, as it made them well suited for homesteads or backyards, and in fact, the breed has been called the Yard Pig. In the southeastern United States, where they were especially popular, they were usually left to forage for themselves. One of their useful services was catching and eating snakes, as well as rodents and other small creatures that might otherwise have found their way into households. Today, they make popular pets and are appropriate for small farms and "hobby farms."

It is not known how closely related they are to the much larger Red Guineas, but the word "guinea" suggests that they originated in West Africa. Some Red Guineas are known to have come from the Canary Islands, where they thrived after presumably being brought over from Africa to live on the island and provide food for passing sailors.

HAMPSHIRE

Though it carries the name of an English county and is based on the Wessex pigs that are bred in that county, the Hampshire is an American breed. First imported from Hampshire in 1832, the breed was called the Thin Rind for almost sixty years because there was so little fat under the skin; it remains one of the leanest breeds in the United States, and in fact in the world. For this reason it is frequently used as the sire for crossbred pigs in many countries. Another name had been the McKay, after a Kentucky livestock shipper, and also the Ring Middle, even though the white ring is quite a bit forward of the pig's actual middle. It was given the name Hampshire in 1890, acknowledging its place of origin.

Thanks to the Hampshire's reputation, specimens were exported from the United States to Britain in 1968, and from Canada in 1973. These had been carefully selected, and one of the boars from Canada that had been a champion at the Toronto Royal Show went on to become champion at England's Royal Show. In the latter part of the twentieth century, genetic

importation from the United States has often been via embryo transfer or boar semen rather than via live pigs.

The breeding of Hampshires in Britain has been kept separate from the breeding of the similar British Saddlebacks. The most obvious difference between the two is the carriage of the ears—lop in the case of the Saddleback, prick for the Hampshires.

HEREFORD

The handsome Hereford Hogs have the same distinctive coloring as Hereford cattle. The chestnut bodies with white faces and socks are the same on the piglets as on the full-grown pigs. In the early 1900s, two separate breeding programs arrived at this type of pig. One program was in Missouri, the others in Iowa and Nebraska, in the heart of North America's pig-breeding area. The body color came from Durocs, and the white socks and head from Poland China stock. When the National Hereford Hog Record Association was formed in 1934, it was sponsored by the Polled Hereford Cattle Registry Association.

While coloring was perhaps uppermost in the minds of the early breeders, by chance or by design, they created a pig with many desirable qualities. The pigs are especially efficient, needing less feed than most to gain weight; they also mature quickly and are calm and easily contained in their pastures.

KUNEKUNE

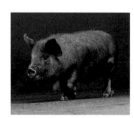

This little breed from New Zealand is also called the Maori Pig. The name Kunekune means "round and fat" in the Maori language. The origin of the breed is uncertain, but it is believed to have been part of the general movements and diaspora of Polynesian peoples and their domestic creatures around the Pacific. It is also possible that the pigs are the descendants of animals brought by whaling ships from Southeast Asia.

The Maori appreciated the Kunekune's ability to forage, eat grass, and thrive on scraps. These pigs are easy to handle and can live outdoors year-round as long as they have shelter from strong sun and heavy rain. In spite of their many assets, they came close to extinction in the 1970s. When a select breeding stock of only eighteen specimens had been carefully increased to nearly two hundred, it was realized that survival chances would be increased if some were exported, thus guarding the pigs against disease or natural disaster on the New Zealand farms.

In 1992 some were exported to England, and subsequently a few were introduced in Ireland, France, the Netherlands, and the United States. Since Kunekunes are attractive, friendly, and small, they have a

strong appeal as pets, and it helps that there is a wide range of colors and patterns, even among piglets from the same litter. The piglets are hard to resist, but people wanting them as pets should bear in mind that an adult Kunekune can weigh up to 130 pounds. This is small by pig standards, but more substantial than most dog breeds.

Since the pigs are unusually hairy, people might not notice the small growths under the chin. These are variously called tassels or wattles, and they seem to serve no purpose. They are called *piri piri* by the Maori.

LANDRACE

Landrace Pigs originated in Scandinavia and have spread around the world. The breed has the exceptional ability to improve other breeds when crossed with them, and it is estimated that as much as 90 percent of hybrid gilts in North America and western Europe have Landrace blood. The litters are large, with piglets that grow quickly while being well cared for by the Landrace sows, either indoors or out. The meat is relatively lean and well suited for pork and bacon.

Danish Landrace Pigs first came to the United States in 1934, and have been a major contributor to bacon production ever since. Crosses with Yorkshires have been very successful. The British Landrace Pig Society was formed in 1950, after importations from Sweden, and became a model for testing, evaluation, and an efficient national herd book. Pigs came to England in a roundabout way via Northern Ireland, the Isle of Man, and the Channel Islands. Later Landraces from Norway and Finland were imported directly to England, as well as to Scotland and Northern Ireland.

LARGE BLACK

In the days of long sea voyages, crews took livestock on board to provide fresh milk, eggs, and meat. Any surplus animals might then be sold at the home port, which is likely how black-skinned pigs from the Far East entered seaports in southwest England, such as those in Cornwall; the Large Black is sometimes referred to as the Cornwall. There may also have been Neapolitan blood.

At one time there was an Eastern Large Black from England's East Anglia, but these merged with the Large Blacks from Devon and Cornwall. Similarly, any other regional black breeds in southern England were eventually incorporated into this family. The Large Black Pig Society was formed in 1889, and breeders exchanged stock in order to establish conformity. The breed was much admired in the early decades of the twentieth century.

Large Blacks have been exported to more than thirty countries, many of them with hot climates. They are especially popular in Australia and New Zealand. An attempt is currently being made to introduce them

to Haiti in order to help replace the local black pigs, which had been ubiquitous until "Baby Doc" Duvalier ordered their slaughter throughout the country because of a very local case of African swine fever.

The Large Black, content to graze outdoors, is hardy enough to endure Northern Hemisphere winters. Dark skin can be unpopular with a butcher's customers, but more recently buyers are learning to appreciate the taste superiority of certain pedigree breeds, regardless of skin color.

LARGE WHITE / YORKSHIRE

Pigs descended directly from Britain's Large Whites are called Yorkshires in many countries, and although the name Large White is hardly known in those places, their Yorkshires are essentially the same breed. The breed, or breeds, have so many advantages that they are the most popular in the world. Large and long-limbed pigs from the county of Yorkshire were crossed with breeds from Cumberland, Lincolnshire, and Leicestershire, and initially they were not completely white. First gaining attention at the Windsor Royal Show in 1831, the Large White was officially recognized in 1868, and well-enough established by 1884 to be one of the founder breeds of Britain's National Pig Breeders Association.

It is easy to understand the success of the Large White/Yorkshire. The breed reproduces rapidly and produces exceptional bacon, pork, and hams. The boars are prepotent, and the sows are good mothers to their large litters, providing an ample supply of milk. The breed has a long life expectancy, and although typically raised in large indoor operations, the breed is surprisingly hardy and tolerant of outdoor conditions.

Large White/Yorkshire pigs are a boon to crossbreeding and rotational breeding programs, contributing consistency, good growth rate, and a favorable percentage of lean meat. Sophisticated performance testing has confirmed their merits, and whether by the name Large White or Yorkshire, they have been exported in large numbers to more than sixty countries.

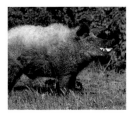

MANGALITZA

Not only does this very hairy breed have a primitive appearance, but its piglets have horizontal stripes, like those of the Wild Boar. The hair of the adults is curly, making them look like "pigs in sheep's clothing." Mangalitzas are from Hungary and Austria. They have only recently been introduced into Britain, and even more recently a few have been exported to the United States, where the spelling is slightly different, ending in "itsa." In Hungarian the ending is spelled "ica," but pronounced the same.

Actually, there are three different breeds, the Red, the Blond, and the Swallow-Bellied, which is a black pig with white underneath. For convenience, the British Pig Association classifies the three breeds as one.

Primitive pigs from the Carpathian Basin were crossed with Sumadija pigs from Serbia in the 1830s, producing the Blond Mangalitza. This was then crossed with Szermium/Szeremer pigs from Croatia, hence the Swallow-Bellied. It was not until 1940 that the Blond Mangalitza was crossed with Szalonta boars, which produced the Red Mangalitza. There was speculation that color also came from the Tamworth or perhaps the Bulgarian Kula Red, two breeds that can actually be pronounced.

The breed declined in the chaos of World War II. It was not until the 1990s that people woke up to its merits and the danger of its extinction. The thick coats protect these pigs from the cold and insulate them from the heat, and the breed is disease resistant. The meat is good, and the sows are good mothers.

There was once a similar pig in England, the Lincolnshire Curly Coat, but it had too much fat for changing tastes and was allowed to become extinct. Earlier, several had been exported to Hungary, where they were much admired, winning prizes at shows in Budapest. Some were mated with Mangalitzas, and their offspring were called Lincolnistas.

In 2006 the English breeder Tony York went to Hungary and Austria to collect enough unrelated specimens in all three colors to establish the breeds in England. He was aided by the veterinary surgeon Jenkin O. Davies and by Christoph Weisner, of the Mangalitza Pig Breeders Association in Austria. Overcoming many problems through diplomacy and perseverance, the expedition was a success, culminating in an offer from Marcus Bates, president of the British Pig Association, to maintain the country's herd book for this growing breed.

MEISHAN

This Chinese pig is one of the breeds found in the region around Lake Taihu, which is located in north central China, where the climate among the lakes and valleys is mild. With its sagging spine, low belly, wrinkled face, and the long drooping ears of a lop rabbit, it suggests a shar-pei puppy crossed with a hippopotamus; it moves with the lethargy of Eeyore in the Winnie-the-Pooh stories.

However, the Meishan has recently been of great interest to Western breeders due to the fact that the sows have exceptionally large litters. They have sixteen to twenty teats, and it is normal to have the same number of piglets, often twice a year. Litters of thirty to forty can occur, but this is rare.

Unfortunately, although the meat tastes good, it also has a high percentage of fat. Before health concerns over cholesterol, this was not considered a problem, but since the 1980s, attempts have been made to bring the fat to lower levels without losing the prolificacy. This has involved breeding the Meishans with Western pigs.

In 1989, Meishan, Fengjing, and Minzhu pigs were shipped to the University of Illinois and to Iowa State University for crossbreeding experiments. Meanwhile, Britain's Pig Improvement Company was also working with Meishan specimens. In Britanny, the French company Pen Ar Lan used both Meishan and Jiaxin, combining them with a synthetic boar line based on three Western breeds. Subsequent breeding included Landrace, but went back and forth between Meishan and European pigs until they arrived at a good sow line, which they call the Naima.

MIDDLE WHITE

The popularity of this English breed has fluctuated over its 160 years of existence. It is currently classified as rare and endangered, but the situation appears to be improving. The breed came into existence by chance in 1852 when a breeder named Joseph Tuley exhibited some fine pigs that were not big enough for the Large White class in which they were entered, and yet too large to be Small Whites. Rather than disqualifying them, the judges promptly established a new class.

Subsequently Mr. Tuley deliberately bred Large Whites with Small Whites, successfully duplicating the distinctive squashed profile of the smaller pigs while retaining the larger size. The extreme dished face of the Small White occurred from crossbreeding with pigs from China and Siam. Anyone familiar with English bulldogs knows the breathing difficulties that arise from faces like these, and early in the twentieth century, the Small White became extinct.

Meanwhile, the Middle White prospered and was one of the three breeds included in the National Pig Breeders Association's first herd book, published in 1885. Butchers and their clients appreciated the quality of the meat, and in the first decades of the last century, the breed was known as the London Porker. This changed during the food rationing of World War II, and many pork breeds lost favor to breeds better suited to bacon production. More recently, though, the flavor of the meat has generated fresh interest from restaurants and home cooks. A breeders club was established by enthusiasts in 1990. The pigs are now exported worldwide, and are particularly popular in Japan and Malaysia.

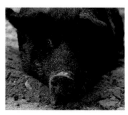

MULEFOOT HOG

The most distinctive feature of the Mulefoot Hog is its hoof, which looks like that of a horse or a mule. Uncloven hooves occasionally occur in other breeds. It is assumed that Mulefoot Hogs are descendants of an unusual Spanish breed of pig in the sixteenth century, and were later crossed with Berkshires, and maybe even Razorbacks. Piglets occasionally have subtle stripes, an indication of genetic ties to wild pigs. The Mulefoot could also be related to the Choctaw, a rare Oklahoma breed that is now mostly feral.

The breed is found mostly in the American Midwest and along the Mississippi Valley. The sows are good mothers to litters of six to twelve piglets, and the adults are efficient foragers. At one time, farmers would drop these pigs off on an island in the middle of a river in spring and leave them to fend for themselves until autumn.

Unfortunately, the breed is now becoming rare: There were perhaps 200 individuals at the beginning of this century, compared to 200 herds at the beginning of the twentieth century. Extinction would be especially tragic since pork from the Mulefoot is considered delicious.

OSSABAW ISLAND HOG

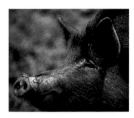

Off the coast of Georgia, there is an island where the pig population has been isolated from other breeds for centuries. The pigs on Ossabaw are direct descendants of those brought to the New World by the Spanish explorers and settlers of the sixteenth century. Natural selection has favored certain characteristics best suited to the conditions on the island, and as with many other wild creatures, they have evolved to retain plenty of fat to tide them over periods of food scarcity; this is not necessary in modern domestic pigs that are fed year-round. Certain animal species have evolved to become smaller where space and food supplies are limited, and the phenomenon known as island dwarfism probably affected the Ossabaw population, as they are smaller than most domestic breeds. Like the Wild Boars, they have large shoulders, plenty of coarse hair, and long snouts, and occasionally their piglets have the stripes found in Wild Boars. In the interests of other creatures and plant life on Ossabaw Island, culling keeps the pig population within sustainable limits.

Scientists have studied these unusual pigs and find the island to be a useful laboratory. Though no other pig breeds are allowed onto the island, a small number were transplanted to the mainland, and these are also of interest to scientists. Ossabaw Island is no longer privately owned, so the state will be making ecological decisions in the future.

OXFORD SANDY AND BLACK

With its origins in Oxfordshire, the Oxford Sandy and Black has also been called the Oxford Forest Pig. Because of its appearance, it has also been called the Plum Pudding Pig. The spotted piglets are more like puddings with raisins, and they tend to have brighter coats, almost orange, which gradually fade to a dull sandy color with age, while the spots gradually become blotches. The breed originated in the 1700s, perhaps from Tamworth, Berkshire, and Neapolitan ancestry. Some of the original bloodlines have been lost.

Oxford Sandy and Black sows have large litters and are good mothers. Overall, the pigs are easy to handle, hardy foragers with large well-balanced physiques, and produce a flavorful meat. In addition, their agreeable temperament makes them easy to handle. So it is surprising that a few dedicated breeders have had to save the breed from extinction more than once in the last century. The picture began improving in 1985, when a breed society was formed and management of the herd book was taken over by the British Pig Association. These pigs are now regularly seen at livestock shows, and more people are being introduced to their many fine qualities.

PENNYWELL MINIATURE

Pennywell Farm, not far from Torquay in South Devon, has become a popular destination for families. To develop a pig that would appeal to children and be calm around them, Chris Murray has spent twenty years developing a wonderful miniature pig. The program included both small and normal-size pigs that possessed gentle personalities, and could contribute some color variations. In addition to the small Kunekunes, there have been genetic contributions from Tamworth, Berkshire, Wild Boar, Gloucester Old Spots, Middle White, as well as British Lop, a docile pig that is also from Devon. Some Pennywells have little tassels or wattles under their chins.

In Cambridgeshire, Jane Croft is breeding small pigs that she calls Teacup Pigs. The name was actually coined by the photographer Richard Austin. When they are piglets, the Teacup Pigs are indeed as small as a teacup. They weigh about nine ounces at birth and as adults are no more than about sixty-five pounds. Other farms are working on Micro-Minis and Thimble Pigs, but it will take time to establish pigs that breed to a consistent type.

Since pigs in general are intelligent and friendly animals, with instincts toward cleanliness, it is appealing to breed them down to sizes that make them more manageable as pets than normal pigs. Miniature versions of Poodles, Schnauzers, and even Dobermans have been bred, and many chickens have been miniaturized to become bantams, so smaller pigs have a promising future. However, it is important to remember that pet piglets will not retain all their piglet charm indefinitely.

PIETRAIN

These pigs originated in the village of Piétrain in Belgium and for many years remained a local breed. The ancestry can only be guessed at, but possibilities range from the French Bayeux and Normand pigs to the English Berkshire, Tamworth, and Large White. In the years before World War II, the merits of the Piétrain's lean carcass became known, and the breed spread to other countries, particularly Germany. This

quality worked against this breed during the war, when fat in all meats was highly valued, and it was not until the 1950s that Piétrains regained respect. They have been useful in crossbreeding programs in Scotland, England, and Spain.

The attractive blotches on the hides are surrounded by rings or halos of a lighter color, and this suggests genes from the dark French Limousin pigs, which produced pied offspring when crossed with other breeds. Piétrain shoulders are muscular, and the hams are double-muscled, an unusual feature. The ratio of lean-meat weight to bone weight is very favorable. Unfortunately, the breed's leanness is associated with the gene for Porcine Stress Syndrome, which can literally cause the pigs to drop dead unexpectedly. Consequently, people are wary of raising purebred specimens, more often opting to benefit from the Piétrain's virtues in crossbred animals.

POLAND CHINA

During the nineteenth century, breeders in Ohio experimented with a variety of pigs. Not only are the records incomplete, but the names varied from county to county and from farm to farm. Breeders were, of course, trying to make improvements, but each might have a different agenda, and they were limited by the available boars and sows. One of the breeds that was used successfully in crosses was known as the Big China, brought by Shakers from a farm near Philadelphia.

Pigs that came to be known as Polands were not from that country, but were bred by an Ohio farmer who was Polish, and whose name the locals had difficulty pronouncing. For a while there was a type of pig known as the Poland and China. In 1872 the name was officially shortened to become Poland China. Irish immigrants brought in several Irish Graziers, and in one area there may have been pigs with Neapolitan blood. The breed kept evolving, with different body shapes, sizes, and colors, and late in the century it was primarily a lard pig that could be smoked, salted, or pickled, and then sent south by river transport.

When lard became less popular in the twentieth century, the Poland China became a large pig with a meaty carcass, and the present coloring became established, black with white tips, very like the Berkshire.

RED WATTLE HOG

The most distinctive features of this breed are the growths under the necks. Though these are called wattles, they are much smaller in relation to body size than the wattles on chickens and turkeys, and they appear to serve no purpose. Wattles, or tassels, also occur on Kunekunes and on some Pennywell Miniatures, and very occasionally on other breeds. Wattles can sometimes be seen in historic prints and paintings.

This large pig originated in east Texas. There were two separate lines of red pigs with wattles in the 1970s and 1980s—the Wengler Red Wattle Hog and the Timberlines—and these were then combined. Later, three organizations kept separate registries of the breed, but they declined to unify them, a suggestion that was made by the American Livestock Breeds Conservancy (ALBC). Ultimately the ALBC started a pedigree registration, but the breed has become very scarce.

The rarity of the breed is unfortunate because the sows are good mothers to large litters of ten to fifteen piglets, which grow up rapidly to become hardy animals whose meat is lean, flavorful, and tender. Fully grown, they can weigh between 600 and 1,000 pounds. Their compact build has a "short wheel base," a length-to-height ratio of only two to one.

SPOTTED SWINE

When Indiana farmers bred their animals with pigs from Ohio, as well as with a couple of Gloucestershire Old Spots imported from England, the resulting breed initially had no name. With the Poland China and Big China as ancestors, the breed was referred to as the Spotted Poland China until 1960, when the name was officially changed to Spotted Swine; many people refer to the breed simply as Spots.

The design of the spots is quite random, rather like military camouflage. The breed standard requires that the animals are black-and-white only, with no brown or other coloring. The head itself should never be completely black, and there should be no suggestion of a saddle or belt.

TAMWORTH

Two hundred years ago, many British breeds were being crossed with Neapolitan and Chinese pigs, but the Tamworth was not included in these so-called improvements. It is therefore perhaps the oldest true British breed, descended from the Old English Forest Pig. It retains the long snout of more primitive pigs and is alert and athletic. Its speed and energy can make it hard to control in a show ring. Not only do Tamworths have the hardiness and the dark coloring well suited to outdoor conditions, but they seem to actually enjoy the freedom of the range. Giving them space to move helps to minimize body fat, and they are good pigs for bacon and ham. The distinctive red coloring may have come from various sources: Sir Robert Peel brought Irish red pigs to his Tamworth estate, and his neighbor, Sir Francis Lawley, had red pigs from India. There were also red pigs in Barbados, but it's possible they came from Tamworth stock, not the other way round.

When Tamworth numbers diminished in the early twentieth century, traffic between countries that had previously received Tamworths helped to ensure genetic strength, with imports from Canada to Britain being especially significant. It was thought that some inbreeding had affected hardiness and prolificacy, so the return flow of pigs from Canada and elsewhere was important. Tamworths are primarily found in the English-speaking world, so Australia, New Zealand, and the United States have well-established herds. In the 1970s, numbers were so low that boars were imported back to Britain from Australia. The color of these Australian animals was preferred over the darker shade of red found on the Canadian Tamworths.

VIETNAMESE POTBELLIED

In the 1960s, exports of these little pigs from Vietnam into Sweden, the United States, and Canada went to zoos and to medical research. Since pigs have many internal organs similar to our own, they are used in research, and since it is easier to deal with smaller creatures than with full-size farm animals, the Vietnamese Potbellied is one of the breeds used. In addition, it has been used in the development of many small hybrids, also for medical research, including, for example, a miniature created by Göttingen University in Germany, and another used in crosses with the Landrace to produce the Minisib, which is used in Russia.

At the same time it is a popular choice for children's zoos and petting zoos, as well as at farms that encourage family visits. In Britain the tiny Kunekune from New Zealand is more common, as well as recently bred miniatures such as the Pennywell Miniature and the Teacup Pig.

Potbellieds were first used as pets in the United States in the 1980s, and they were briefly very fashionable. Some of these pet owners may have become a little dismayed as their piglets grew to the size of large dogs; nonetheless, there are still plenty of pet owners who are enthusiastic about these intelligent creatures, which are instinctively clean and can be house-trained.

In southeast Asia, pigs, poultry, and fish are the main sources of animal protein. In Vietnam itself, the raising of pigs of all sizes tends to be on a small domestic scale, involving ingenious harmony. For example, the pigs' manure can fertilize water plants and rice paddies, which in turn help to feed the pigs. Cooperation within a community of people involves an efficient system of specialization and division of labor during the various stages of the life and death of the pigs, and for many the financial rewards transform the animals, quite literally, into "piggy banks."

WELSH

Some believe that the Welsh was originally introduced to Wales by the Vikings, which would be supported by the breed's similarity to the Scandinavian Landrace—it also has a long, straight, white body and lop ears. The ears of the Welsh are particularly long, with the tips often meeting in front of the face close to the nose, restricting the animal's vision. The legs are short in relation to body length but muscular.

In the first half of the twentieth century, societies were formed in different parts of Wales, and herd books were published. Eventually there was a Welsh Pig Society, and in the early 1950s it joined what would become the British Pig Society. The Welsh was the third most popular breed in Britain, with only the Large White and the Landrace outnumbering it. This is no longer the case, but the Welsh has many admirers, and the pigs do well in livestock shows.

A TAXIDERMY **WILD BOAR**

WILD BOAR

The Eurasian Wild Boar, sometimes referred to as the Russian Wild Boar, is the genetic ancestor of all domestic pigs. Tens of thousands of years ago, when humans started domesticating certain creatures for their meat, milk, and eggs, and hides—in fact, almost all parts of their bodies—the Wild Boar was found to be more suitable than other wild pig species. The sows had large litters with enough teats for several piglets to feed simultaneously, and the meat was good. Wild Boars were found all over Asia and Europe, preferring scrubland, woods, and forests, and they could tolerate extremes of climate, surviving on a wide range of food sources. They ate mostly a vegetarian diet but would also eat worms and grubs. Specimens in the northwestern region of the European-Asian landmass were larger than those in Southeast Asia.

Wild pigs have always been hunted for their meat, which often left orphaned piglets available for domestication. The ancient Wild Boars had large heads and massive shoulders but were slimmer in the hindquarters—much more athletic than the creatures we breed today. In medieval times, hunting the heavily tusked males with spears was considered a manly and dangerous sport, as the boars could be a fierce and formidable quarry. Boars' heads were often used in heraldic designs to suggest warrior-like qualities.

Many Wild Boars are still found in the wild, and though not native to North America, enough of them were imported as prey for hunters that in many places they are plentiful and have become destructive pests. Often they are hunted simply to reduce their numbers and thus reduce the damage they do to crops. These feral pigs sometimes penetrate fences and mate with domestic pigs. The piglets from these unions carry the distinctive horizontal stripes found on wild piglets.

Today there is a growing interest in the lean meat and taste of Wild Boar, and there are now a few farms in France, England, and the United States that breed them for restaurants.

— SPECIES —

BABIRUSA

The Indonesian Babirusa is distantly related to the pig, and it has been suggested that the Babirusa is also related to the hippopotamus; its hairless gray skin suggests this, but the animals live on different continents. Also known as the Deer Hog, the Babirusa has a strange pair of tusks that grow through its skull, similar to the horns of a deer or an antelope. In the males, these upper tusks curl back toward the eyes, seemingly one of nature's design flaws. In captive specimens, the tusks are carefully shortened with a saw to avoid the possibility of slow suicide; fortunately, the tusks are negligible in females. The Babirusa's diet consists mostly of vegetable matter, including leaves, but they are opportunistic omnivores, and will eat birds, rodents, insects, and carrion. The females travel in small groups with their young, while males, who will do battle for harem rights, tend to be solitary. Babirusas live in tropical forests near water, but like so many other creatures in that part of the world, their numbers are shrinking from habitat loss and illegal hunting.

BEARDED PIG

Weighing about 225 pounds, the Bearded Pig is large, and it also has a fairly large range, including the Philippines, Sumatra, Borneo, and the Malay Peninsula. They migrate in large groups, which is unusual for pig species. Life expectancy is around sixteen years, and the average litter contains four piglets. In rain forests and mangrove swamps they will eat worms and carrion, but for the most part their diet consists of vegetable matter. They have been observed following gibbons and macaques in the trees above them, feeding on fruit that is rejected or dropped accidentally.

CHACOAN PECCARY

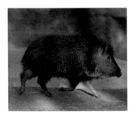

Though Peccaries are not pigs, they are the most piglike animal native to the Americas. Weighing around seventy-five pounds, the Chacoan is among the largest of the group, and it is also the most endangered. Its habitat is the hot and dry region of South America known as the Gran Chaco, which ranges from northern Argentina and western Paraguay into southern Bolivia.

The Chacoan Peccary avoids contact with humans, preferring remote spots where it can feed in daylight. Herds usually consist of a dozen animals, and they communicate with a wide range of chatty grunts. Once also called the Giant Peccary (until a larger species was discovered and given this name), the Chacoan's ability to handle cactus plants has earned it the odd nickname: the Iron Kidney.

RED RIVER HOG

This handsome pig lives in sub-Saharan West Africa, including Gambia and the Congo, where its enemies are hyenas, leopards, and lions. It in turn preys on lizards, mollusks, insects, and eggs, and will also eat carrion. Its principal diet is vegetable matter, however, and its strong snout can dig deep for roots, sometimes with the help of its sharp tusks.

Living in swamps and along riverbanks, the Red River Hog travels in small herds. There are three or four piglets in a litter and they grow up to around 150 pounds. The Red River Hog is closely related to the Bushpig, which is similar in appearance, but without the red coloring. The two never cross paths, since the Bushpig lives in East Africa.

VISAYAN WARTY PIG

The Visayan Warty Pig was discovered only fairly recently in the Philippines, but already its population is declining. As usual, the culprits are habitat loss and hunting. Visayan Warty Pigs can do great damage to crops with their rooting, which, besides their meat, adds another reason for hunting them. In addition, they are susceptible to diseases carried by domestic pigs. Since the warts on the head of the males are almost imperceptible and the females have none at all, it is surprising that the species has been named for them. Orphaned piglets, attractively striped, have sometimes been adopted as pets, and are apparently extremely playful.

WARTHOG

The Warthog lives on the open plains of sub-Saharan Africa, where it enjoys the savanna vegetation. To graze on shorter grasses, the animals will go down on their front knees, which grow callouses and become hairy. The snout serves as a powerful rooting tool. Its large broad head gives the Warthog an unbalanced appearance, but it is a fast runner, able to reach speeds of around thirty miles per hour, while at the same time holding its tail upright like a little mast. When a Warthog feels threatened, it will back into a hole or corner and face its enemies, including the big-cat predators, with its four formidable tusks. Like a camel, the Warthog is able to survive for long periods without water, but, like elephants and rhinos, it loves a cooling mud bath.

WESTERN FOREST HOG

This female came to the San Diego Zoo from a small zoo in Conakry, Guinea. Believed at first to be a small, or young, specimen of the Giant Forest Hog, experts later realized this was incorrect, and so she was reclassified as a Western Forest Hog, the first of her species to be discovered. Very little is known about the species as of this writing.

ACKNOWLEDGMENTS

This book would not have been possible without the help and cooperation of a great many people. I will start by thanking people in England since that is where I started work on this project. Since I began with the Royal Show in Warwickshire, I would first like to thank Viki Mills. Most pigs at the show were brought there to be judged, but Viki arranged for other interesting breeds to be on display for visitors. In addition she was helpful with many important contacts. Her colleague, Marcus Bates, chief executive of the British Pig Association, gave me useful information and introduced me to the Rare Breeds Survival Trust.

Julie Bublaitas was my cheerful and efficient contact with the Royal Agricultural Society of England, which was tragically staging the final edition of the Royal Show in 2009. Will Wolf arranged for a good space for my temporary studio, Sarah Baskerville made sure that ample electricity was supplied to that space, and Liz Wicks was my hard-working photo assistant. Andy Gready, of Jimmy's Farm near Ipswich, was a constant source of help, advice, and information at the show, and subsequently Malcolm and Su Hicks, Wendy Scudamore, and Sue Rankin brought interesting pigs and piglets. There is not enough space to thank all the owners and breeders who led their pigs in front of my cameras, but I hope they will be pleased when they see their animals in the book.

I was able to photograph pigs and piglets at several farms, and for their hospitality and active help, I want to give enthusiastic thanks to the following: Andrew and Maureen Case, Heather Royle, Julian and James Newth, Mark Graham, Teresa Griffin, and Ian and Tracey Bretherton, as well as Janice Wood, Steve Richardson, and Martyn Wood. Chris Murray of Pennywell Farm helped me with the photography of his charming Pennywell Miniatures.

In addition to all those mentioned, I had interesting telephone or e-mail exchanges with Tony York, who brought Mangalitzas to Britain with much persistence and diplomacy, and Jane Croft, who has developed the popular Teacup Pigs. And thanks to my friend Nick Rootes for help with the Churchill anecdote. I visited the Chester Zoo, so my thanks to Lynne Ainscough there. Finally, I thank my cousins Jock and Susie Green-Armytage, whose house in London was home, staging post, rest and relaxation, and a place to borrow their son's Wellington boots.

The agricultural show I attended in the United Sates was the Keystone International Livestock Exposition in Harrisburg, Pennsylvania. Jim Sharp was the show manager and Harry Bachman the swine supervisor. I am indebted to both for generous cooperation. I also want to thank photographer Steve Mapes, who gave me some tips from his extensive experience with livestock, and provided me with marshmallows, which were often useful in gaining the attention of many of my subjects.

In New York State, I particularly want to thank Jenny Blaney and Ted Mead at the Pig Place; Tony Yezzi and Jennifer Small at Flying Pigs Farm; Paul Alward at Veritas Farms; Steve and Jennifer Patinka with their Hereford pigs and piglets; and Pam Marabini at her home on Long Island, where we worked with the help of Ramona Barbosa. At the beautiful Stone Barns Center, Rebecca Sherman and the livestock staff introduced me to pigs and piglets thriving in the estate's woods. Michael Grady Robertson introduced me to the pigs at the Queens County Farm in New York City. In New Hampshire I photographed at Sulbar Farm; my thanks to Shirley Sullivan. At the farm on the Mount Vernon Estate I worked with the help of Lisa Pregent, Olivia Taylor, and Damara Gailliot.

Most of the wild pig species were photographed at the great San Diego Zoo. Curby Simerson, curator of mammals, and Elaine Chu were extremely helpful, and I also thank Gary Berg. At the Wild Animal Park, I appreciated the help of Andy Blue, Peggy Sexton, and Dave Luce. At the Virginia Zoo in Norfolk, I thank Louise Hill, Anne Vogt, Diane Paluzzi, and Timothy Easter. At the Bronx Zoo in New York, I took some photographs as an ordinary zoo visitor.

In Texas, Terry Ruddick had planned to take me out to see some feral Wild Boars, but we were thwarted by serious road-closing floods in the area we planned to visit. So Dr. Terry Todd led me to some taxidermy specimens at Cabela's that represented boar-hunting activity. At the University of Illinois Dr. Clifford Shipley put me in touch with Glenn Bressner, and we did some fine work with Meishan pigs, assisted by fellow Animal Sciences Researcher Doug Franklin. My most frequent pig wrangler and piglet handler was my wife, Judy, who spent part of her childhood on a Wyoming farm, and accompanied me to four locations.

I also wish to thank the many individuals who helped me make contacts, gather information, and offered advice: Anneke Jakes at the American Livestock Breeds Conservancy; Dr. Mary Smith at Cornell; Heath Putnam, Mangalitza expert; Jane Mancaster, Javelina authority; Kay Wolfe; Dr. Lane Corley; Dr. Tim Barnum; Don Butler, president of the National Pork Producers' Council; Katie Sinclair at Ontario Pork; Raphael Bertinotti and George Luis Lowen of Pen Ar Lan Farms in Canada and Brazil; Paul and Charlie Kimball; Lori Richardson; Donna Woolham; Ridgway Shinn; Bill Heffernan; and Nancy Shepherd and Ruth Campbell. My apologies to anyone I have overlooked.

At my publisher, Abrams, much credit goes to senior editor Andrea Danese, managing editor Kathleen Go, and designer Kara Strubel. Also involved at Abrams were director of calendars and custom publications, Lindley Boegehold, and freelance editor Susan Homer.

Sources

By far the most helpful book was Valerie Porter's *Pigs: A Handbook to the Breeds of the World* with illustrations by Jake Tebbit. A thorough and scholarly work, it was published in 1993 by Helm Information in England. In 2001, the Yale University Press published *The Encyclopedia of Historic and Endangered Livestock and Poultry Breeds* by Janet Vorwald Dohner, which covers a number of farm species, with sad news about the way the world is squandering hard-won breeding achievements.

Andy Case wrote the text to accompany Andrew Perris's pig portraits in *Beautiful Pigs,* with some history and interesting notes about the breeds. It was produced by the Ivy Press for Thomas Dunne Books, an imprint of St. Martin's Press. Andy Case, himself a successful pig breeder, also wrote *Starting with Pigs,* which is a practical book that contains general information about several specific breeds. It is from Broad Leys Publishing in Essex, England.

The American Livestock Breeds Conservancy and the British Pig Association both publish leaflets about breeds both common and rare. A great deal of information is often contained in a single sheet. I also liked Val Porter's *British Pigs,* a small volume in the Shire Publications series.

I recommend the 1992 Harry N. Abrams book, *The Ubiquitous Pig*, by Marilyn Nissenson and Susan Jonas. It is scholarly yet entertaining, reviewing pigs in literature, art, and popular culture. There are also some interesting facts in an article written by Kent Britt in the September 1978 edition of *National Geographic* under the title "The Joy of Pigs."

Some of this book's anecdotes, in part or in whole, came from Professor Bamfield's Rare-Breed Pigs website (www.bamfield.eu), and there were two story contributions from Pam Marabini. Valerie Porter's description of the pig tragedy in Haiti was amplified and brought up to date by Ragan Sutterfield's article in *World Ark*, published by Heifer International, and Kay Wolfe has written about the export of Large Blacks to the island in "The American Livestock Breeds Conservancy NEWS."

PAGE 1: ONE-WEEK-OLD VIETNAMESE POTBELLIED PIGLET, Buckles

PAGE 2–3: SIX-WEEK-OLD KUNEKUNE PIGLET

PAGE 4–5: MIDDLE WHITE PIGLETS

PAGE 6–7: MIDDLE WHITE, *Lewin Dorothy 3* or Alice

PAGE 8–9: MEISHAN GILT, *4001*

PAGE 10–11: SEVENTEEN-DAY-OLD HEREFORD PIGLETS

Editor: Andrea Danese
Designer: Kara Strubel
Production Manager: Jules Thomson

The Library of Congress has cataloged the hardcover of this edition as follows:

Green-Armytage, Stephen.
 Extraordinary pigs / by Stephen Green-Armytage.
 p. cm.
 ISBN 978-0-8109-9742-4 (alk. paper)
 1. Swine breeds. 2. Swine breeds--Pictorial works. I. Title.
 SF395.G74 2010
 636.4--dc22
 2010030873
Paperback ISBN 978-0-4197-0005-7

Printed and bound in Singapore
10 9 8 7 6 5 4 3 2 1

Abrams books are available at special discounts when purchased in quantity for premiums and promotions as well as fundraising or educational use. Special editions can also be created to specification. For details, contact specialmarkets@abramsbooks.com or the address below.

ABRAMS
THE ART OF BOOKS SINCE 1949
115 West 18th Street
New York, NY 10011
www.abramsbooks.com